I hope thi[s]
back man[y]
memories...!
I Love You
Emily Lynn

IMAGES
of America

VINCENNES

1930–1960

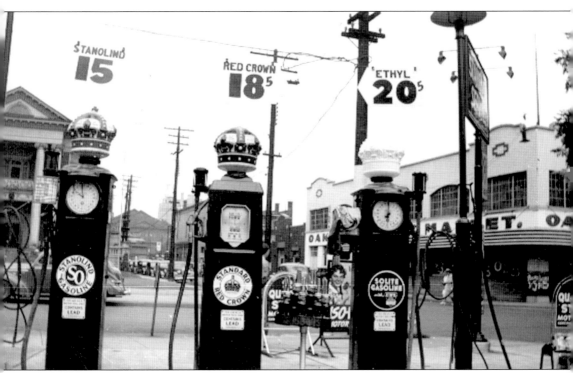

Gas pumps at the Standard station, at Fourth and Busseron Streets, around 1936 symbolize the impact of the automobile on Vincennes. Gasoline is cheap: Standard is 15¢, Red Crown 18¢, and Ethyl 20¢. Prices are pegged on five-tenths of a cent rather than the nine-tenths used now. In the background to the left is the Elks Club; to the right is the Oakley Market, originally a Maxwell car dealership.

IMAGES
of America

VINCENNES
1930–1960

Richard Day, Garry Hall, and William Hopper

ARCADIA
PUBLISHING

Copyright © 2006 Richard Day, Garry Hall, and William Hopper
ISBN 978-0-7385-3983-6

Published by Arcadia Publishing
Charleston SC, Chicago IL, Portsmouth NH, San Francisco CA

Printed in the United States of America

Library of Congress Catalog Card Number: 2005937660

For all general information contact Arcadia Publishing at:
Telephone 843-853-2070
Fax 843-853-0044
E-mail sales@arcadiapublishing.com
For customer service and orders:
Toll-Free 1-888-313-2665

Visit us on the Internet at www.arcadiapublishing.com

CONTENTS

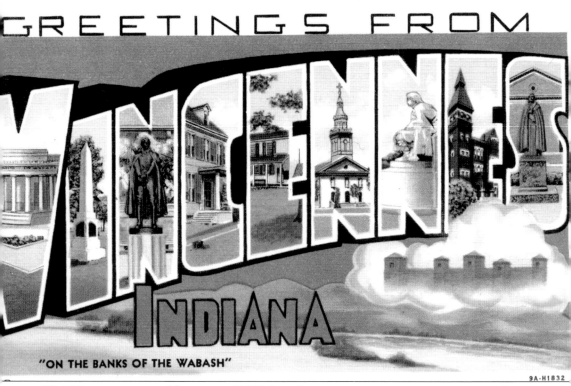

GREETINGS FROM VINCENNES INDIANA

"ON THE BANKS OF THE WABASH"

9A-H1832

This Vincennes postcard from around 1950 shows historic sites important to community identity: the George Rogers Clark Memorial, the grave of General Washington Johnston (founder of Indiana Masonry), the statue of George Rogers Clark, the William Henry Harrison Mansion, the Indiana Territory capitol, the Old Cathedral, the statue of Francis Vigo, Vincennes University, and the statue of Fr. Pierre Gibault.

INTRODUCTION

As the first and oldest town in Indiana, Vincennes is rich in history. It had an important role in the American Revolution and later was capital of Indiana Territory. This book focuses on a more recent time: from 1930 to 1960, the period of the Great Depression, the New Deal, World War II, and the postwar Truman and Eisenhower years.

Most of the pictures in this collection were made by commercial photographer Lester B. Read, who described himself as "Your Hometown Photographer." For over 50 years, from 1922 to 1975, Read captured images of local people, places, and events in crisp large-format photographs.

These pictures are organized into chapters entitled "Downtown," "Around Town," "Special Events," "World War II," and "Industry and Government." There are fascinating views of stores, clubs, theaters, churches, factories, groceries, and gas stations—many of which are gone or greatly changed. There are also unchanging events, such as Labor Day and homecoming parades, and Fourth of July picnics at Gregg Park.

All three of the authors are lifelong residents of Vincennes. Richard Day is cultural administrator of Vincennes State Historic Sites. Garry Hall is fleet sales manager for Vincennes Ford and an avid collector of vintage photographs. William Hopper is a retired elementary school principal and an antiques dealer.

The locale of this book is the area in and around Vincennes. Vincennes is a venerable city, with a history going back to its founding by the French in 1732. Many books have already been written about its role in the American Revolution, when it was captured by George Rogers Clark in 1779 and, later, when it was capital of Indiana Territory from 1800 to 1813. This book focuses on the period between 1930 and 1960—the period of the Great Depression, the New Deal, World War II, the Truman era, and the Eisenhower era.

Locally, the Great Depression era was marked by the closing of businesses such as Vincennes Furniture Company, Vincennes Phonograph Company, and Hack and Simon Brewery. Other businesses continued to supply much-needed jobs, notably, Brown Shoe Factory and Vincennes Bridge Company. There were bank failures, too: the Knox-Harrison Bank in 1928 and the First National Bank in 1933. Many people lost their life savings, and many farms and businesses were repossessed. There were community gardens out on St. Clair Street and soup kitchens. The period was marked by drought, dust storms, and heat waves.

The New Deal brought about the building of the Memorial Bridge and the George Rogers Clark Memorial, culminating in the dedication of the memorial by Pres. Franklin D. Roosevelt. Gregg Park and Kimmel Park were also built at this time. Streetcars were replaced by buses as a way of getting around the city. Automobiles were relatively scarce, and the town was still a collection of neighborhoods, each with its own businesses and stores within walking distance.

During World War II, George Field was created. There were aviation cadets everywhere. German prisoners of war were housed next to Kimmel Park. There was the draft, ration books, victory gardens, bond drives, and scrap drives. The newspaper was full of stories of local people in the service, posted to faraway theaters of action, and the pictures of young men in uniform, with the captions "Wounded," "Missing in Action," "Prisoner," or "Killed."

During the Truman era, a levee was constructed to protect the town from floods of the Wabash River. Vincennes University moved to a new campus; many of its buildings were war surplus. During the Eisenhower era, a highway bypass and shopping centers were constructed, beginning the exodus of business from Main Street.

In motion picture palaces and, later, at the drive-in, folks could see movies with local stars Alice Terry and Buck Jones. Later favorite son Red Skelton could be seen on the new medium of television. On summer evenings, the civic band performed in the park band shell. Nearby was Rainbow Beach, the only place to cool off in the days before air-conditioning. Although much of those times and many of the people are now gone, their photographs remain as a reminder of how it was to live in Vincennes.

One

DOWNTOWN

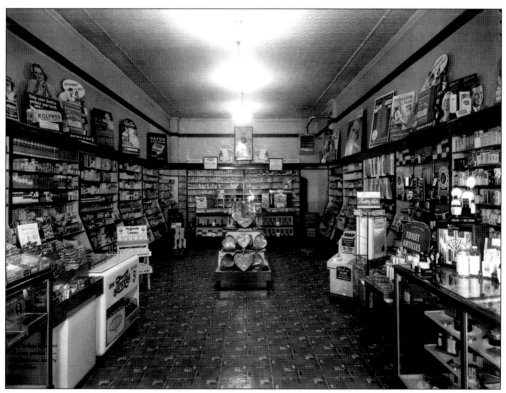

Kramer's New Drug Store (inside view), located at Fourth and Main Streets, on February 6, 1939, represents the many vibrant businesses that flourished downtown from 1930 to 1960.

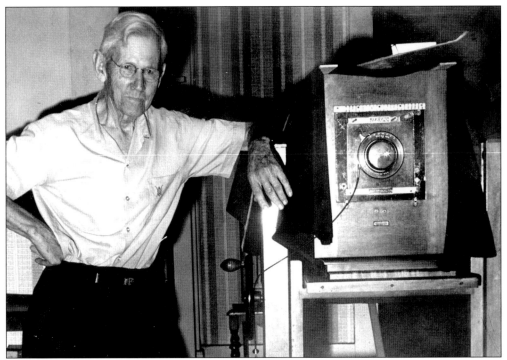

Lester B. Read (1890–1975) leans on his trusty view camera in July 1970. For over 50 years, from 1922 to 1975, his lens captured life in Vincennes. He left behind a file of hundreds of negatives, identified by subject and date. These photographs came into the possession of Garry Hall and are the basis of this book.

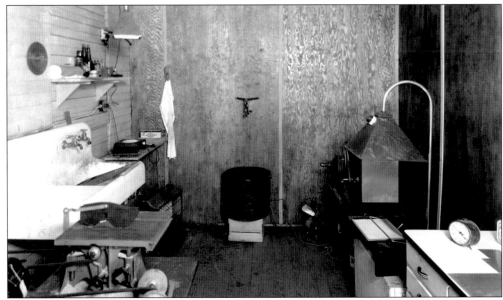

This is the engraving room of Read Studio, at 508 Main Street, on February 5, 1939. L. B. Read bought the shop in 1922 from photographer Edward A. Biersdorfer. Earlier it was owned by photographer Edward S. Clark. In this engraving room over the years, Read prepared his many finely crafted photographs.

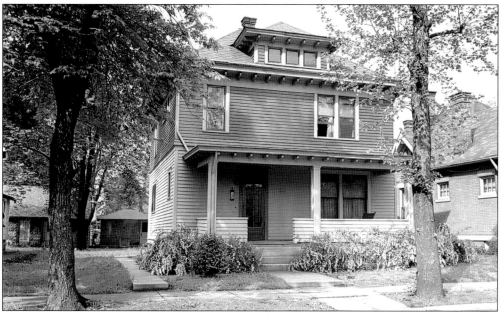

L. B. Read's home, at 1217 Busseron Street, is seen in this 1947 photograph. The house was new when Read moved here in 1922 with his wife, Lucia. His children, Muriel, Perry, and Vernon, were born here. Read lived here his entire life. The house still stands.

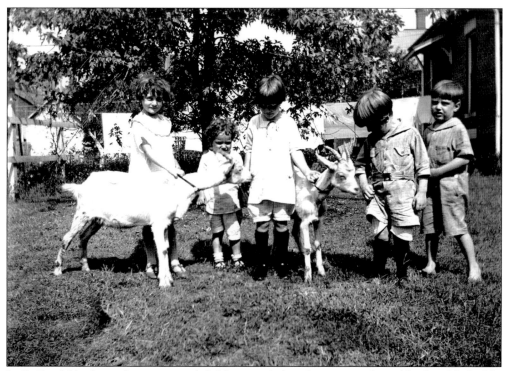

L. B. Read liked to take pictures of children, including his own and neighborhood kids. His children are seen here around 1930 with a couple of other kids (goats). It was common to have livestock in the backyard at this time.

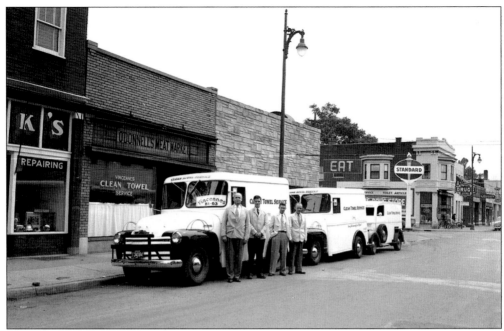

Shown here is Clean Towel Service, located on Tenth and Main Streets, in September 1949. Nearby are Piper's Grocery, Smith's Drugstore, Beard's Hardware, a gas station, a meat market, a hatchery, a restaurant, and three taverns. In the 1930s, Vincennes was still a city of neighborhood businesses, but in the postwar era, that changed as the population started moving to the suburbs and the businesses moved out to the highway.

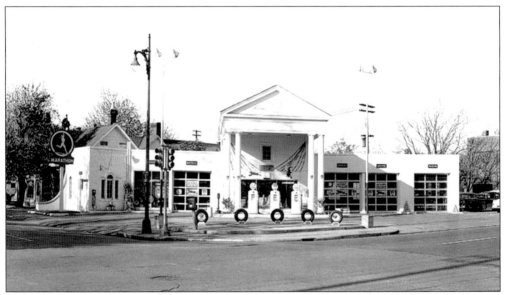

Shown here is Joe Kopta's Marathon service station, located at Seventh and Main Streets, on October 30, 1953. When it opened as a Linco super station on September 4, 1930, the station was noteworthy for its appearance as a southern mansion. Four tall white pillars supported a portico to shelter the pumps. The garage was to the right, and a ladies' lounge, decorated in pale green, was to the left. The station was torn down in August 1970.

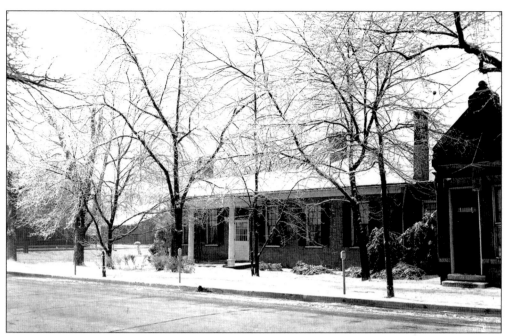

Theo Agnew's home, at 617 Main Street, was frosted with snow on January 7, 1950. The house was built in 1809. It belonged to stagecoach driver and impresario William Green in 1843 and later to his granddaughter, Molly Griggs. It was razed in 1958 for a savings and loan company.

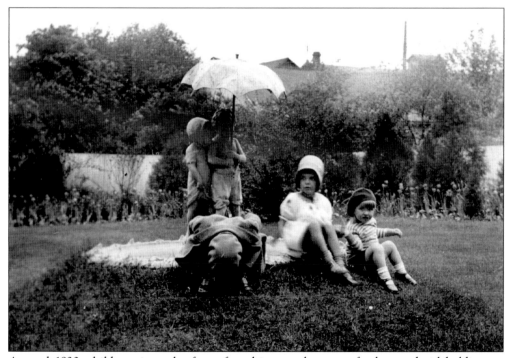

Around 1930, children sit at the foot of a white metal statue of a boy and girl holding an umbrella, surrounded by a birdbath, in the beautiful tulip garden behind the home of Molly Griggs, at Seventh and Main Streets. This statue was a well-known landmark.

This building, located on Sixth and Main Streets, was built about 1925 as a Nash Motor Company showroom, selling Nash and Ajax motorcars. It was built in the latest textured brick style and was a large open building, allowing many uses like a Chrysler-Plymouth dealership and, for a long time, the popular Stephens Café. In 1958, when this picture was taken, it was used by Social Security. It was torn down in 2005.

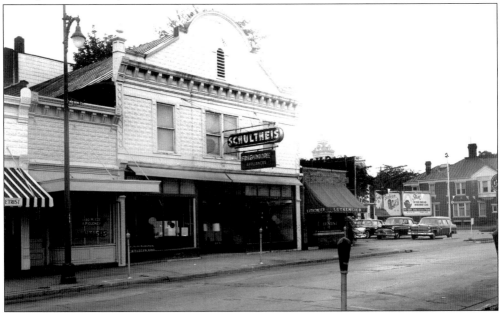

Schultheis and Sons Furniture Store, at Sixth and Main Streets, is seen here in 1956. It was originally built as the Second Presbyterian Church in 1862, when the congregation split over the Civil War. When August Schultheis took over in 1905, he removed the spire and added a tin front. The store was sold in 1974. The Sunbeam Bread sign, in the right background, featured a swinging "Little Miss Sunbeam."

A boy flies a model airplane near Sixth and Main Streets around 1930. In the background is Zeno and Jules Grumieaux's Restaurant, noted for its chili soup and hot fish sandwiches. The city's first stoplight, set up on June 5, 1926, hangs overhead.

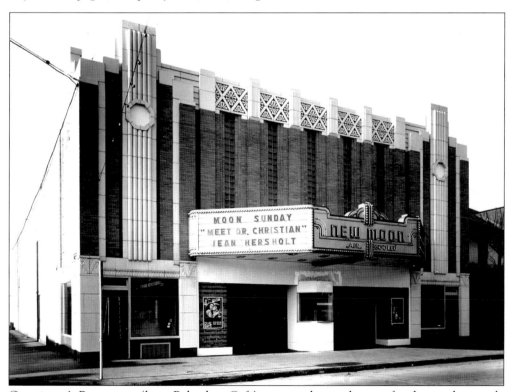

Grumieaux's Restaurant (later Belvedere Café) was razed to make way for the art deco–style New Moon Theatre, shown here on December 9, 1939. Five days later, its first movie was *Golden Boy*, starring Barbara Stanwyck and Robert Holden.

Gardner Funeral Home, near Fifth and Main Streets, was celebrating its 140th birthday as Indiana's oldest continuously owned family business on September 19, 1956, when this picture was taken. It was founded in 1816 by Andrew Gardner as a furniture shop. Gradually, Gardner shifted from making coffins to undertaking. In 1916, the business occupied the old Bonner-Allen Mansion, built in 1843.

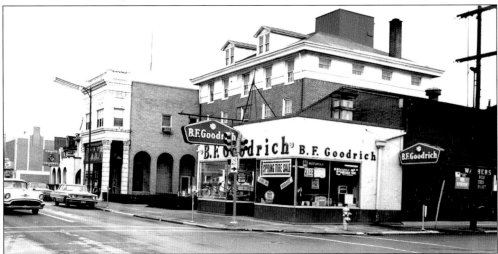

Looking toward Sixth Street, this view shows Fifth and Main Streets. To the left of Gardner's is Paul C. Schultz's flower shop, built of buff brick in 1916, with its distinctive arched pergola. Schultz lived in an apartment above the shop. His slogan was "We grow our own flowers." He had a greenhouse at First and Shelby Streets.

The Moon Theatre, located at Fifth and Main Streets, advertises Red Skelton's 1941 movie, *Panama Hattie*, costarring Ann Sothern. It began as a vaudeville theater called the Red Mill in 1908, with a red windmill on its marquee (still visible here, without its wheel).

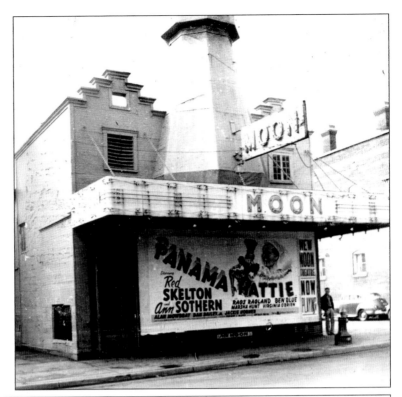

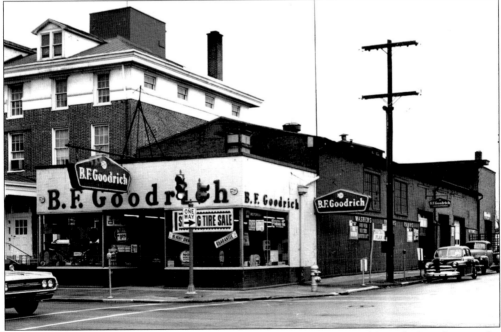

In 1949, when B. F. Goodrich took over the old Moon Theatre, at Fifth and Main Streets, the company removed the windmill and entranceway and added a concrete block structure, where it sold tires, bicycles, and appliances. The back portion of the building was the old theater, used for the tire and battery shop.

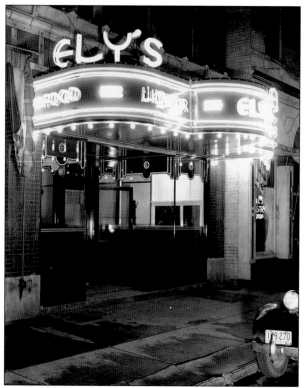

In 1938, the glitzy neon-lit marquee of Ely Crain's café and tavern, at Fifth and Main Streets, gave a showy nightclub appearance to downtown Vincennes. After the drought of Prohibition, the city had developed a powerful thirst, which was served by over 20 taverns within the city and numerous roadhouses such as the Dixie Tavern, on Highway 41 south, and the Terrace Garden, on Highway 41 north.

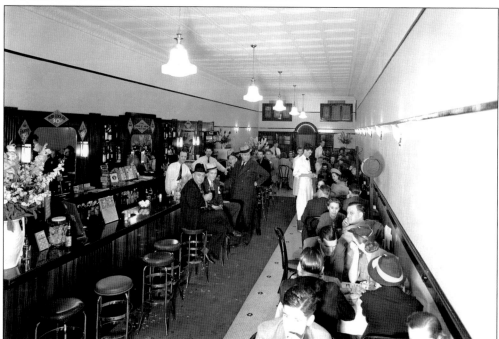

Ely Crain's tavern, which served the after-theater crowd on Saturday nights, had a white tile floor and a beautiful wooden-backed bar. During the war years, the tavern was a popular watering hole for George Field cadets. Its motto was "Where good friends meet."

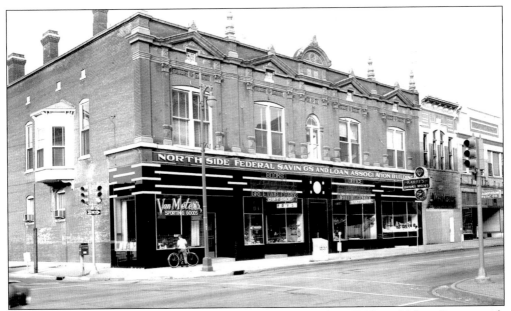

This picture, from September 24, 1960, shows Hoosier Supply at Fifth and Main Streets, with its distinctive black tile covering. Next to it is the remains of Van Meter Sporting Goods Store, which burned in 1959. The store was well known for Ray Van Meter's exotic collection of hunting trophies, which included a black bear, longhorn ram, mountain lion, and elk. After the fire, Van Meter relocated on the corner until repairs were made and he could go out and shoot more trophies.

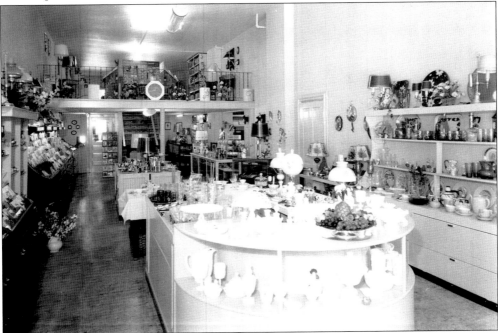

This is the inside of Hoosier Supply on April 4, 1951. The store, owned by Milton Waymire, sold books and school and office supplies. Considered the best gift shop in town, it featured Hummel figurines.

19

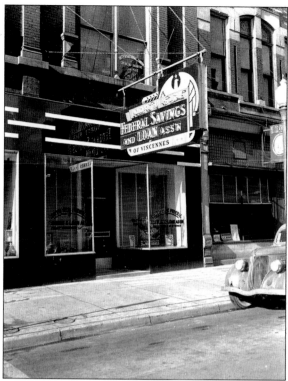

North Side Federal Savings and Loan Association is seen at its new location, at 427 Main Street, in 1943. (It seems never to have been located on the north side.) It had just moved into the Bishop's Block, next to Hoosier Supply. Designed by architect Dietrich Bohlen, the business block was named for Bishop Chatard, who had it built in 1888.

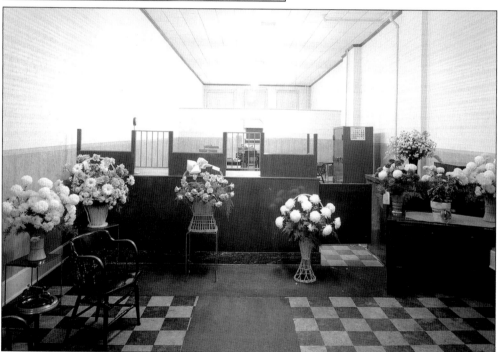

The inside of the North Side Federal Savings and Loan Association is seen here during the celebration of the grand opening in its new location in November 1943, as evidenced by all of the floral arrangements from well-wishers. It specialized in monthly reduction home loans.

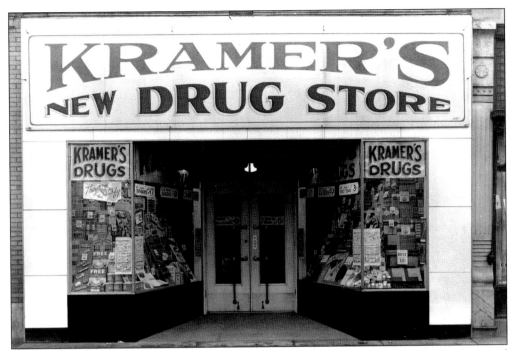

Kramer's New Drug Store, at 417 Main Street, opened in 1928. Earlier the Duesterberg and Kramer Drug Store was located in the Graeter Building, at Third and Main Streets. In 1928, the Graeter Building was torn down and replaced with Kresge's five-and-dime store. Duesterberg moved across the street, and Kramer's moved into the store shown here.

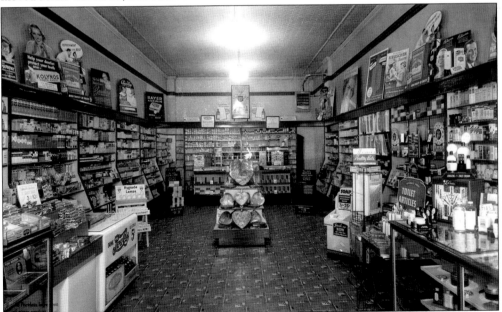

The interior of Kramer's New Drug Store is depicted in this 1939 photograph. The arrangement is typical of drugstores in the 1930s, 1940s, and 1950s, with lots of advertising placards on top of shelves crammed with beauty and health products. There was also a lunch counter serving sundaes, milk shakes, and lunch. Note the Valentine's Day candy display in the center.

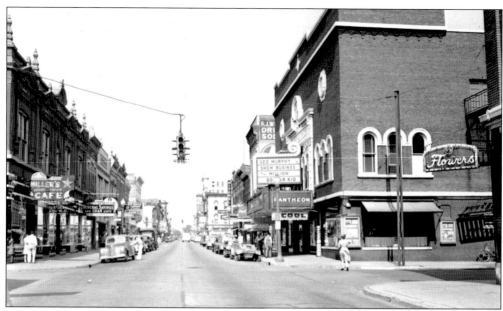

In this picture, looking down Main Street from Fifth Street, the Pantheon Theatre is on the right. In front of the theater, a captured German Kubelwagen (equivalent of the Jeep) is displayed. This picture dates from September 20, 1944. Showing at the theater are *Show Business*, with George Murphy, and *Million Dollar Kid*, with the Bowery Boys.

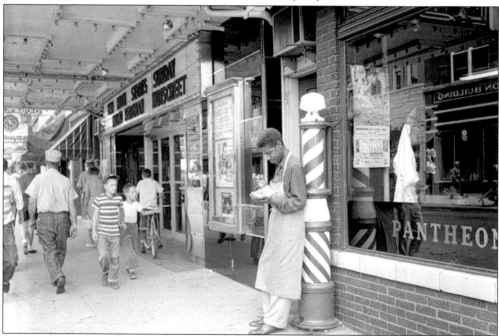

Dawson Taylor, a well-known porter at Pantheon Barbershop, helps celebrate the Watermelon Festival on August 1, 1958. The marquee in the background advertises the Alfred Hitchcock movie *Indiscreet*, starring Cary Grant and Ingrid Bergman. The barbershop was a three-chair shop where one could get a haircut by Gib Finke, Bill Corrie, or Bill Whitsett and one's shoes shined by Dawson Taylor.

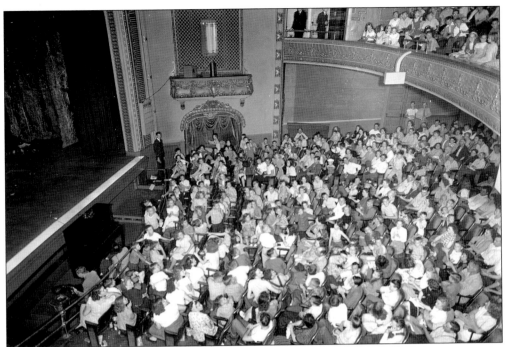

This picture, taken from the balcony of the Pantheon Theatre on June 20, 1947, shows a capacity crowd gathered for a special children's program. The theater held 1,200. This gives a good idea of the elaborate décor of the picture palace. Movies were changed three times a week. Romantic films were shown on Sunday, "date night." Fridays and Saturdays were "kid days," with a western or an adventure movie.

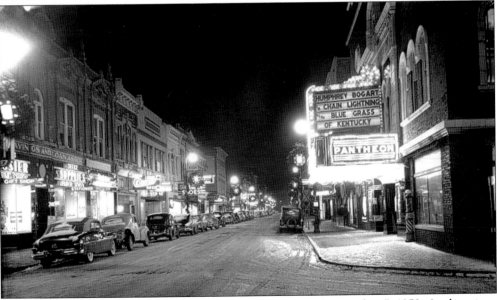

The area at Fifth and Main Streets is shown on the night of December 7, 1950. At that time, downtown was the commercial center of town, especially at Christmas. It was exciting to go downtown, with all the lights and decorations. The windows were filled with special holiday displays. Note the movie at the Pantheon is *Chain Lightning*, with Humphrey Bogart.

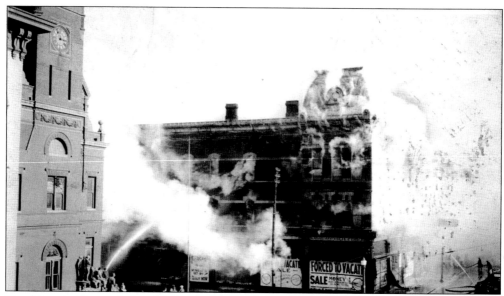

Fire hoses in front of the old city hall pour streams of water onto the William Burchfield Department Store, at Fourth and Main Streets, as it burns on February 6, 1926. The sign on the side of the building reads, "Forced to Vacate: Sale." Originally the building was E. Bierhaus and Sons, Wholesale Grocers, erected in 1880.

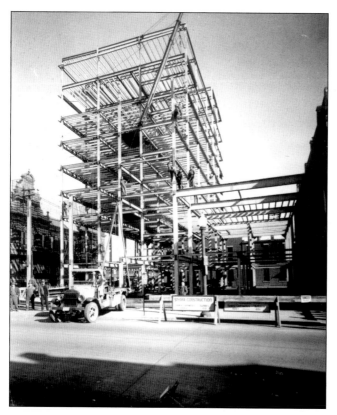

On September 12, 1930, at the old Burchfield Corner, Snyder construction workers stand on steel girders of the proposed seven-story, 120-room George Rogers Clark Hotel. The Depression stopped work, and the "Fresh Air Hotel" rusted until it was dismantled in 1942. In 1950, Hills Department Store was built on the site.

Vincennes City Hall was built at Fourth and Main Streets in 1887. This photograph shows it around 1930, when it was in its prime. The public library, a museum, the Vincennes Chamber of Commerce, the Vincennes Health Department, and a bus station were housed here. The city razed the building in 1950 in an effort to devote Main Street exclusively to commerce.

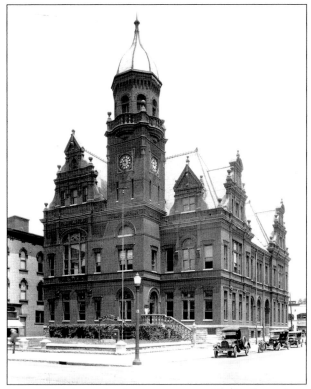

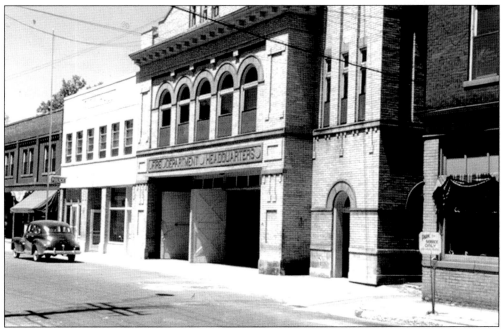

This 1950 photograph shows the new city hall next to the fire department headquarters (Hose House No. 1, built in 1910), on South Fourth Street between Main and Vigo Streets. Down the street to the left is the Lincoln Grill, where the "nighthawks" (newspaper reporters, off-duty policemen, and firemen) gathered to swap stories and gossip.

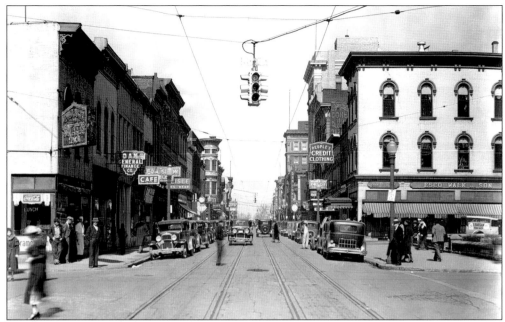

Two sets of trolley tracks can be seen running down the center of Main Street in this 1930s photograph of Fourth and Main Streets. Streetcar service ended in 1937, but the tracks remained for a while. Car traffic was two-way until 1950. The Palace of Sweets is on the left, run by Greek confectioner Pete Bourlakis. Esco Walk and Son Men's Clothing Store is on the right, with display windows looking out on City Hall Place.

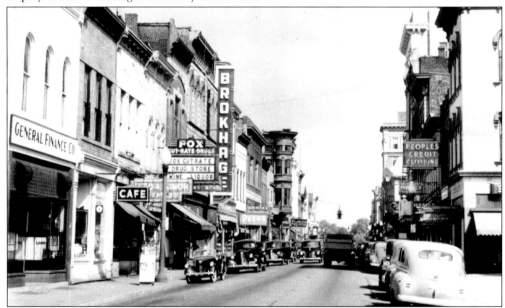

In this photograph of Main Street between Third and Fourth Streets, taken about 1944, traffic is still two-way, but the trolley tracks are gone. Brokhage's Department Store, on the left, billed itself as Vincennes's leading store, featuring dry goods, cloaks, suits, women's ready-to-wear, and clothing for men. Murray's Pharmacy, on the right, opened in 1943. Note the rare Bantam automobile, manufactured in 1938, parked on the left.

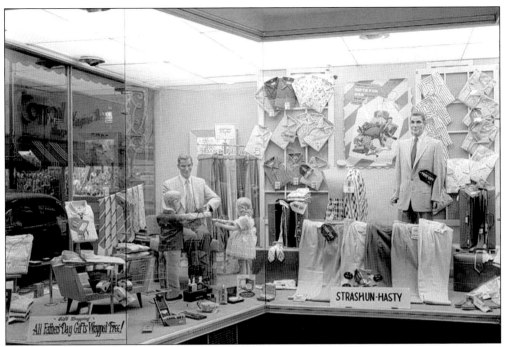

In 1954, businessmen Max Strashun and Jack Hasty bought Brokhage's Department Store and created Strashun-Hasty Department Store. They expanded the inventory to include cosmetics, shoes, gifts, children's clothing, and draperies, and Strashun-Hasty became Vincennes's most up-to-date department store.

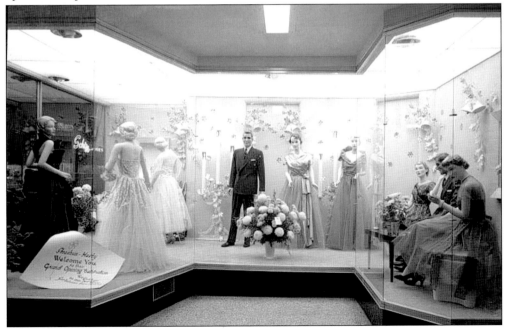

Strashun-Hasty had unique window displays, set back from the sidewalk, that allowed people to walk in and around them. These window displays are from the grand opening of the store, on June 21, 1954. Strashun-Hasty's motto was "the store designed with you in mind."

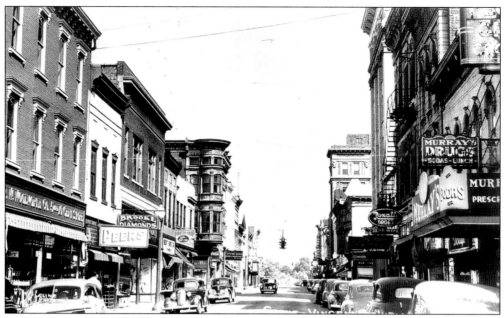

In this picture of the 300 block of Main Street around 1946, F. W. Woolworth's five-and-dime store is on the left. Local merchants called it "an outsider chain store." It was one of the first stores to sell discounted general merchandise at fixed prices, undercutting the prices of local merchants. The tall building on the right is American National Bank.

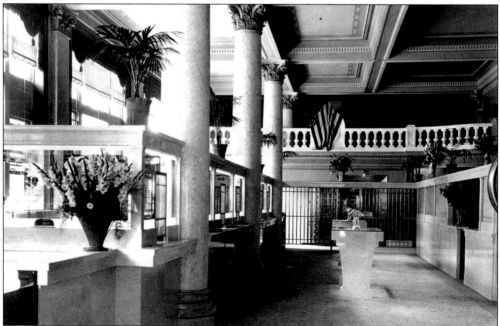

American National Bank began in 1888 as German National Bank but changed its name at the start of World War I. When its new building opened on July 4, 1919, the bank was (and still is) the tallest building in town, at six stories. It was also Vincennes's leading financial institution. This lobby was designed to impress the visitor with its opulence. It features high coffered ceilings, marble columns, and lots of gold leaf.

This 1954 photograph shows the Zarafonetis brothers' Greek Candy Kitchen, which was located at 223 Main Street from 1908 to 1959. With its white-and-black glass tile façade, the shop presented a unique appearance downtown.

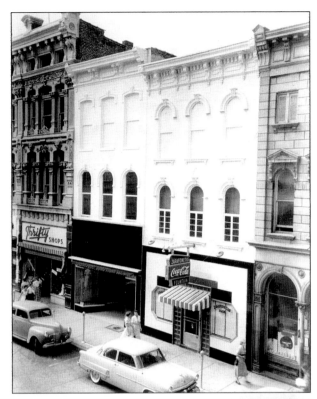

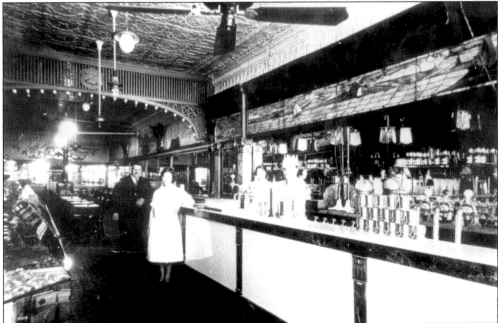

The inside of the Greek Candy Kitchen is seen in this 1927 photograph. On the left is James Zarafonetis, who founded the business with his brother Nick. The business eventually included brothers Pete and Louie as well. The interior had a Tiffany glass back bar and a black-and-white marble counter. The shop featured handmade candy and marvelous Coney Island sandwiches.

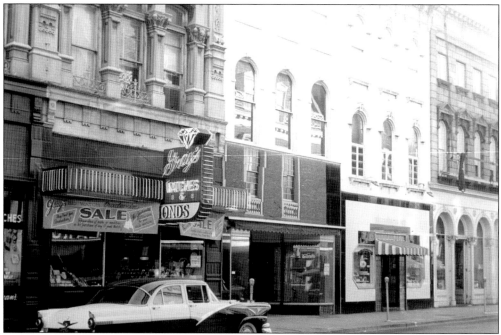

In 1959, the Greek Candy Kitchen and the building next to it were demolished to make way for a new Osco drugstore. This was part of an effort to modernize downtown Vincennes. In the process, a number of downtown buildings, some of them architectural gems, were torn down or substantially altered.

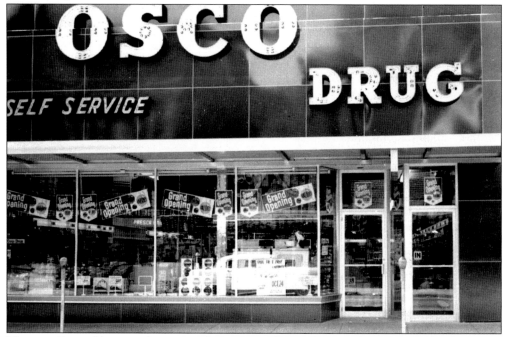

The new Osco self-service drugstore, when it opened in 1960, was adorned with a bright orange porcelain-coated steel façade, in stark contrast with its historic surroundings. In the 1990s, the Drs. Hendrix admirably restored this building and the building on the left as Eyeworks.

In 1938, Security Bank and Trust Company took over the old First National Bank building on Main Street between Second and Third Streets. The building was constructed in 1913 in the purest neoclassical style to resemble a Roman temple. In 1933, there was a run on the First National, and it was forced to close. Security Bank added the large clock in front, which was a landmark on Main Street until the bank moved to its new location at Third and Busseron Streets.

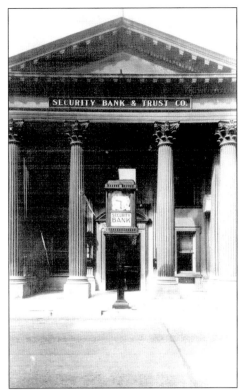

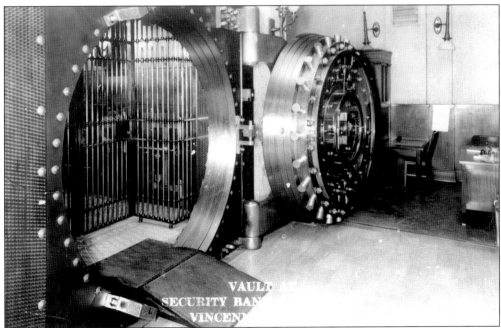

Main Street had to be closed in 1913, when the 16-ton door of the First National Bank was installed. After Security Bank moved out in 1966, the building was used by a music store, and the neoclassical temple front was filled in with a Colonial brick façade. Later, Jewel Craft Jewelry, the present owner, restored the original façade.

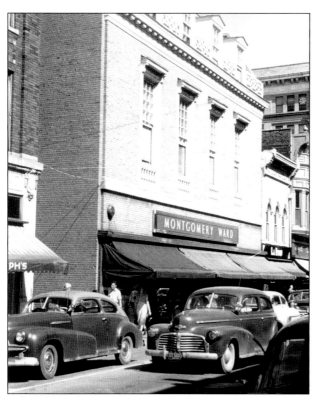

Montgomery Ward Department Store, at 218 Main Street, was built in 1938 with a Colonial-style front that blended with the historical nature of Main Street architecture. This photograph is from 1950.

When it was built in 1916, the Oliphant Building, next to Montgomery Ward, was Vincennes's first skyscraper and its tallest building. A "human fly" was attracted to scale its height. Three years later, the building was surpassed in height by the American National Bank. This picture is from October 10, 1941. For many years, it housed Joseph's Women's Clothing Store, owned by Joseph Yosowitz.

This is a view of Main Street, from Second Street, on October 10, 1941. On the left are Gimbel-Bond Department Store, Miller-Jones Shoe, and the Oliphant Building. On the right are Sears Catalog Office (in the old German National Bank) and R&M Shoe Store, which had a fluoroscope, enabling parents and children to see whether their feet fit in the shoes.

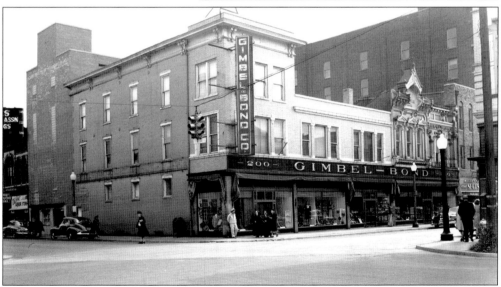

This is the old Gimbel Corner, at Second and Main Streets, on October 1, 1947. Adam and Solomon Gimbel, Bavarian Jews, came to town in 1842 as pack peddlers. In 1845, they rented a building at Second and Main Streets where, in 1857, Adam Gimbel built the three-story brick store, which still stands. Eventually the store consisted of five buildings, extending up Main Street. In 1899, Jacob Gimbel, a nephew of Adam, started Gimbel, Haughton, and Bond, later Gimbel-Bond. It closed in 1981.

This view, looking west, shows the corner of Second and Main Streets just before these buildings were torn down in November 1931 to make way for Patrick Henry Plaza, between Main and Vigo Streets. The three-story building is the David Bonner Building, the oldest business structure in town, built in 1822. At the time it was razed, it was Emison Hardware Store.

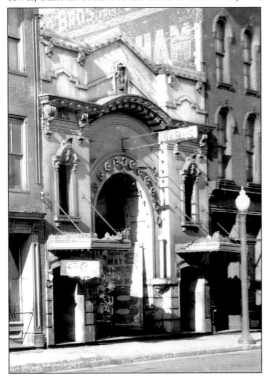

Lyric Theatre stood next to Emison Hardware. It had its beginning in 1907 as an open space between two buildings, with a 16-by-20-foot movie screen. There was no roof, and it was consequently called the Airdome, billed as "the coolest place in town." It later became the elaborate movie palace depicted here, which was torn down in November 1931.

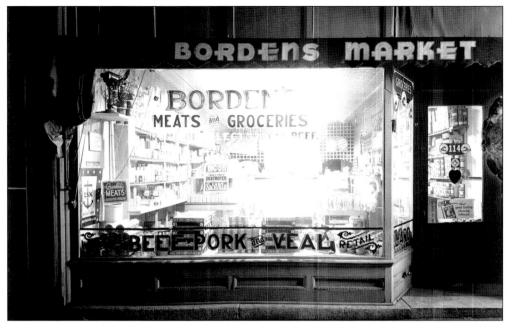

Borden's meat and grocery market, at 114 Main Street, is seen in 1943. James and Alonzo Borden were known for "Quality Meat, Always Fresh," and especially for their fresh-sliced deli sandwiches. In the 1960s, they also sold fresh-cut French fries and fried chicken. Note the poster advertising the Edward G. Robinson movie *Destroyer* at the New Moon and Fort Sackville Theaters.

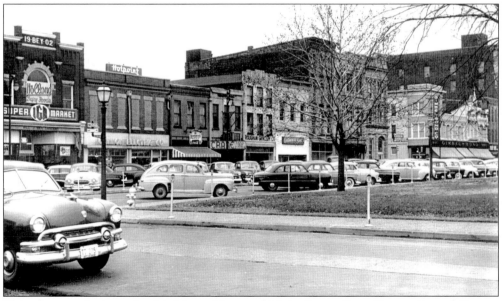

This photograph shows Patrick Henry Plaza and Main Street, from First to Second Streets, in 1949. Note the brand-new Ford in the foreground. The buildings are, from left to right, William Bey's Grocery (since 1902), Cannon Electric (offering Hotpoint appliances), Borden's Quality Market, Crane's Tavern, Roughan's Grocery, Charles Campbell's Auto Accessories (the Continental Store), and Citizen's Insurance Agency.

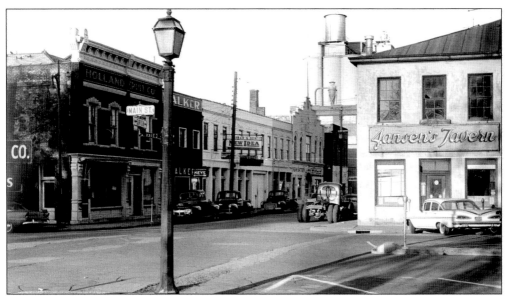

Looking toward Busseron Street, this view is of First and Main Streets in 1959. To the right is Jansen's Tavern (located in the oldest building on Main Street, the Burtch and Hannah Grocery, built in 1829). To the left are Holland Fruit Company (in the old Baugh Brothers Beer Distributor store), Walker's Key Shop, and Organ Battery Shop (in the old Terre Haute Brewery Distributors building, built in 1902).

Vincennes Seed Company, at 26 North First Street, is seen here in 1959. Farmers parked their wagons catercorner in the jockey lot and bought seeds here. Built in 1837 as the A. B. Daniels Grocery, it became the Geneva Hatchery and was the Old Town Players Theater in the 1970s and then the Vieux Carre, a New Orleans–style restaurant. It is now a massage center.

Two

AROUND TOWN

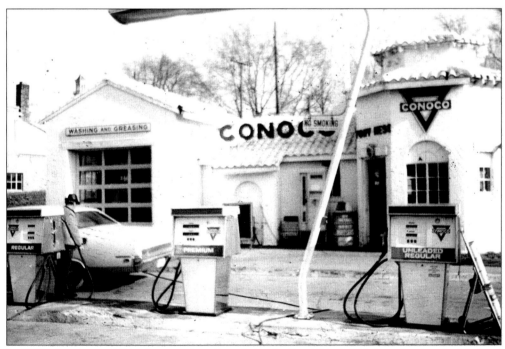

In 1928, the city prohibited gas stations from being built within 1,000 feet of a church. Marland Oil Company, in order to get permission to build at Ninth and Main Streets across from St. John's Church, promised its station would be in the architecturally distinctive Spanish Mission style. Shown on March 11, 1975, the Conoco service station is little changed from when Tony Hess started here in 1935. It was the longest-operating gas station under one name.

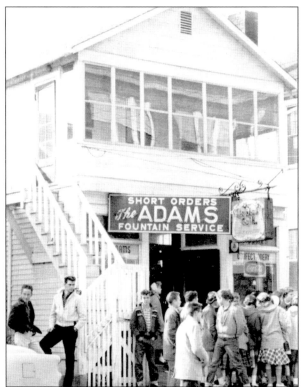

In the 1950s, Adams Soda Shop stood across from the Adams Coliseum, on Buntin Street. It was started as Adams Confectionery by Lincoln High School coach John L. Adams. Adams sold it to Kenny Benson, who operated it until it was torn down to make way for a student park.

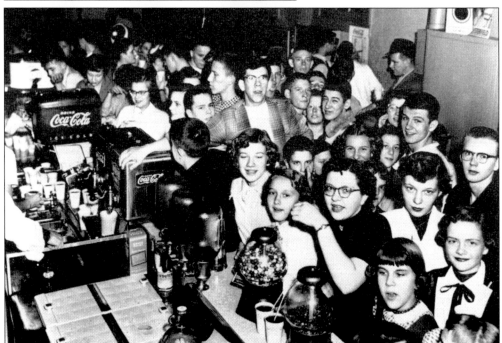

Lincoln students jam Adams Soda Shop for lunch in 1954, which was before school lunch programs existed. It was also crowded before and after basketball games at the Coliseum. Alice Soda Shop, at Seventh and Buntin Streets, had more room but was not as popular.

In 1957, Pat's Drive-In, at Second and Harrison Streets, was the place to go for after-game celebrations with the team and cheerleaders. When the drive-in installed call-in parking stalls across the back lot, customers stopped coming because they could not drive around to see who was there.

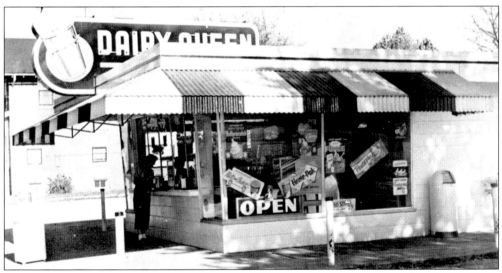

The Dairy Queen, at Sixth and St. Clair Streets, was part of the teenage driving circuit on Friday and Saturday nights in 1956. The route also included the A&W Root Beer Stand, on Washington Avenue; Frostop Root Beer, on Sixth Street; the Red Barrel, across the bridge; Pat's, on Second Street; and a drive down Main Street.

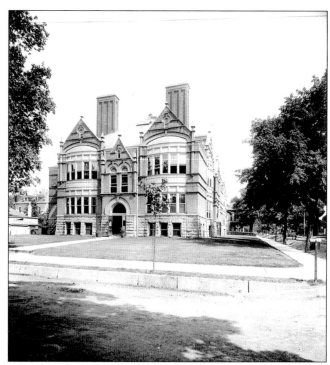

Vincennes High School was built in 1897 at Fifth and Buntin Streets. In 1910, an addition was built on the side facing toward Sixth Street. This photograph shows the school as it looked in 1916, when it was given the name Lincoln High School. In 1927, another addition extended the school to Sixth and Buntin Streets. In 1955, the original high school was razed (leaving the 1927 addition) to make way for a new addition.

While the new Lincoln High School was under construction, students were distributed to various places about town, including the First Baptist Church, the public library, and the Young Men's Christian Association (YMCA), to name a few. Shown here is the part of Lincoln High School completed in 1957, at Fifth and Buntin Streets. It was replaced by a new Lincoln High School, on Hart Street Road, in 1988, whereupon the old school was renamed Clark Middle School.

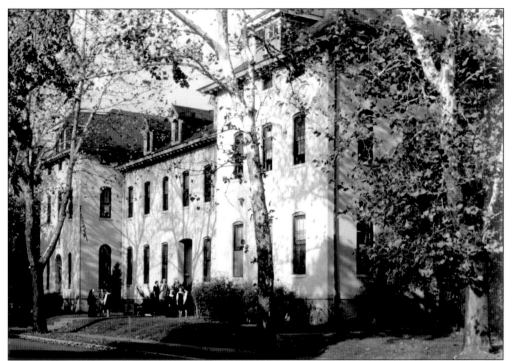

This photograph from around 1960 shows St. Rose Academy, a Catholic girls' high school operated by the Sisters of Providence. It was built in 1885 on Fifth Street between Hart and Seminary Streets in place of an earlier St. Rose. In 1964, a new St. Rose was built at Fourth and Hart Streets. The old building was demolished in 1977.

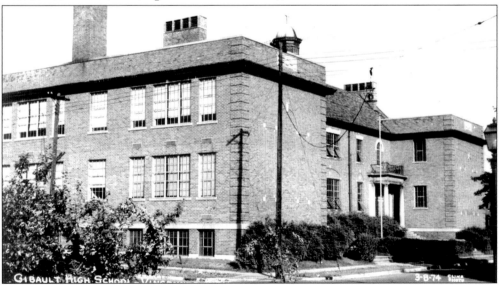

Taught by the Brothers of the Sacred Heart, Gibault High School for Catholic boys opened at Second and Barnett Streets in 1925. The high school closed in 1935 due to the Depression, and the building was used as St. Francis Xavier parochial school. It reopened in 1947 as Central Catholic High School, taught by the Christian Brothers. Since 1971, it has been the coeducational Rivet High School.

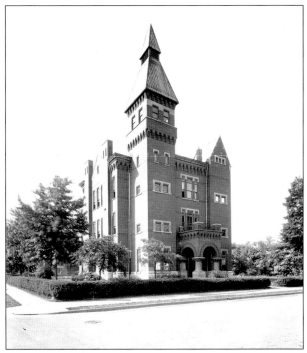

In 1853, Vincennes University moved to Fifth and Busseron Streets, where it remained for a century. In 1878, the structure shown in the photograph was built. It was used until 1953, when the university moved to its present campus. When the old building was torn down in 1954, the short columns supporting the arched entrance were saved and used for the ceremonial entrance to the new campus.

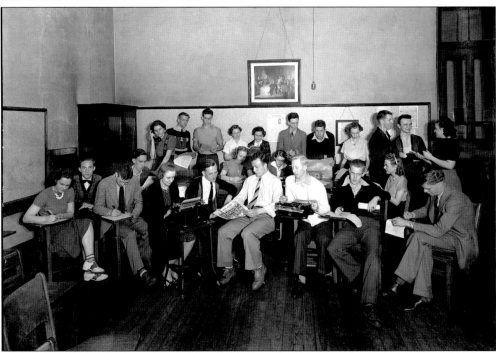

This is a classroom in the old Vincennes University building in the late 1940s. Female students were called coeds, and a dress code forbade them to wear slacks. By special dispensation from the dean of women, coeds who helped with the campus move in 1953 were allowed to wear denim trousers for the first time. Note the coed on the left wearing saddle oxfords, the height of campus style.

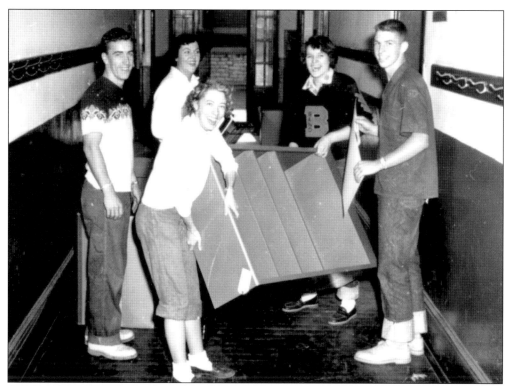

On October 12, 1953, Vincennes University moved to its new campus. On moving day, students and faculty worked together to transport everything from the old building to the new administration and classroom building in an improvised fleet of cars, pickups, and moving vans. That night, students celebrated with a hop (the last dance in the assembly hall on the third floor of the old Vincennes University).

This is Vincennes University's Matthew W. Welsh Administration/Classroom Building in 1953. The university acquired Harrison Park from the city, and this became the nucleus of the campus. The first structure was the administration building, at First Street and College Avenue (originally Hickman Street), followed by the library in 1959, the student union in 1960, and the gymnasium in 1961.

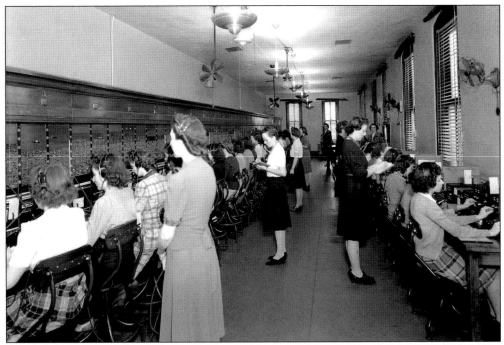

Operators work the switchboards at Bell Telephone, at 17 North Fourth Street, in 1942. After picking up the receiver, the operator would say, "Number, please." The caller would give the number, and the operator would make the connection. During the 1926 Burchfield fire, just across the alley, dedicated operators remained at their posts. Dial telephones replaced operators in 1959, and Vincennes went to touch-tone telephones in 1965.

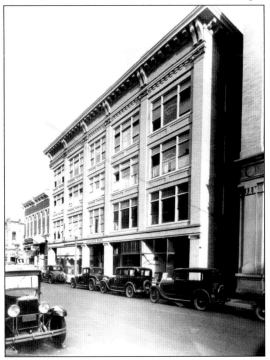

The LaPlante Building stands on the east side of Third Street between Main and Busseron Streets in 1932. The biggest building in town when it was built in 1910, it had offices for businesses and professionals. The Jewel Café can be seen at the corner. It was a popular gathering place for civic organizations.

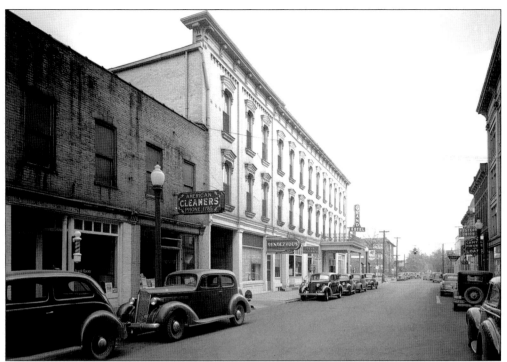

This 1942 view is looking down Third Street toward Busseron Street. On the left are Frank Racey's Barbershop, Powder Puff Beauty Parlor, and the Grand Hotel. Built in 1875, the hotel had 100 rooms. It was extensively remodeled in 1936, and a cocktail bar called the Rendezvous Lounge was added. In 1940, radio station WAOV was located in the hotel.

This view of Grand Hotel was taken at the same time as the one above but from Third and Busseron Streets. By the 1950s, the hotel had problems because its downtown location had no parking. The growing popularity of motels along the highway on the edge of town doomed the hotel. It closed in 1962.

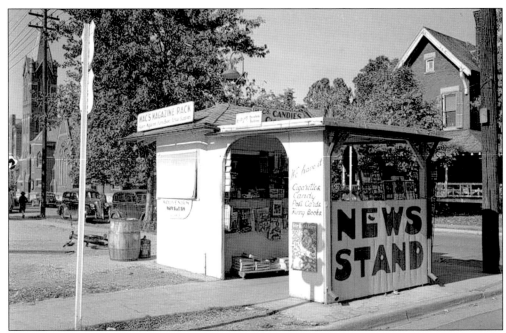

Shown is Mac's Magazine Rack, on Sixth Street near Busseron Street, in October 1944. James McQuaid's magazine rack sold magazines, candies, cigarettes, postcards, souvenirs, and novelties such as marbles and slingshots. It was a small wooden shed, but it boasted, "We occupy the whole building."

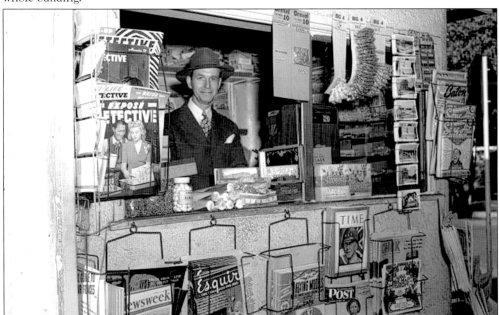

This photograph shows James McQuaid in his newsstand. McQuaid was a star athlete at Notre Dame. In 1936, coaching at Gibault School, he met Marie Lucier of Vincennes, whom he married in 1937. In 1941, McQuaid was diagnosed with multiple sclerosis and was confined to a wheelchair. In the 1950s, his stand was across from the Grand Hotel, and he also coached the Vincennes University freshman basketball team. Finally, he operated the university bookstore.

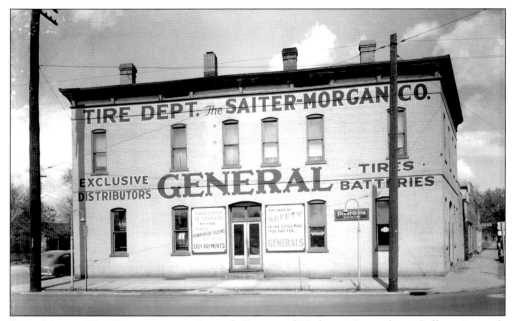

Saiter-Morgan Tire Department, at Seventh Street and Hickman Street (now College Avenue), is seen in the late 1940s. Begun by Harry Saiter and Elisha Morgan in 1891 at Washington and College Avenues, it was the city's premier hardware store for over 50 years. It sold paints, glass, tires, farm implements, guns, appliances, photography, and bicycles including Schwinns. Saiter-Morgan was torn down in 1962.

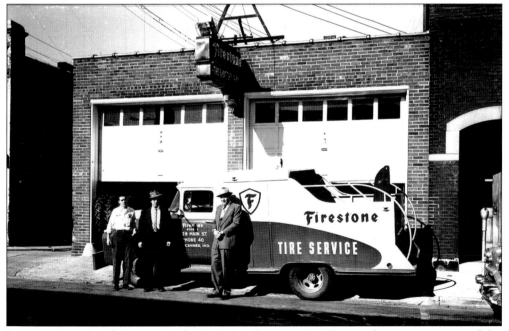

Firestone Auto Supply Store moved to 229 Main Street in 1944. During the war years, automobiles were not produced, and tires were rationed. The store was mostly for automotive parts to keep the cars going. This photograph, from November 20, 1956, shows the garage in the alley behind the store. In 1959, Firestone closed the store.

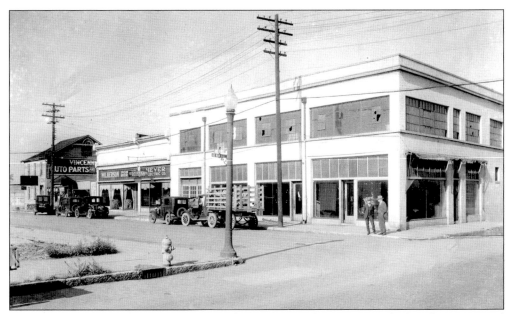

This photograph shows buildings at First and Main Streets about 1930, just before they were razed to build the Memorial Bridge. The building on the corner is the old Robinson and Donaldson Buggy Company, later Empire Motor Company. Next is Orval Meyer Electric Company. In 1922, Orval Meyer invented the first sealed beam headlights for automobiles. Next to it is Wilkerson Sign Company. Vincennes Auto Parts is on the far left.

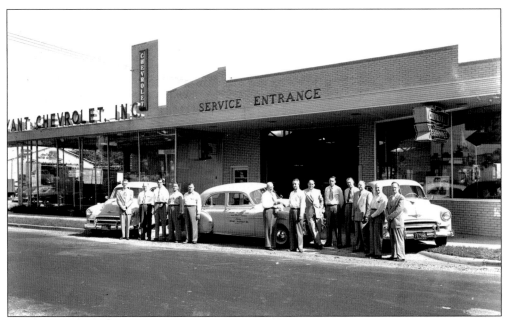

Shown here is Bryant Chevrolet, at Sixth and Vigo Streets, in September 1950. James H. Bryant Sr. is presenting new driver education cars, courtesy of Bryant Chevrolet, to Lloyd Allen, superintendent of Knox County schools. This building was destroyed by fire in the 1950s and was replaced with an almost identical one, which was used until the dealership was sold to Hendrixson Chevrolet in the early 1980s.

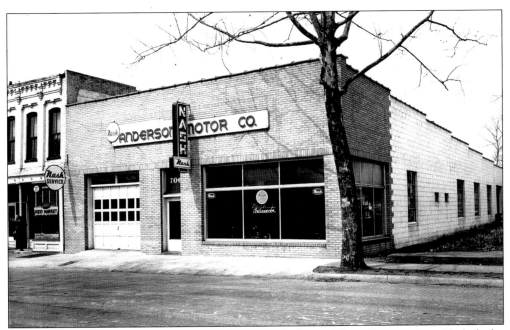

Anderson Nash Motors, at Second Street between Shelby and Scott Streets, was a Nash dealer from about 1947 to 1954, when Nash merged with Hudson Motors to form American Motors Corporation (AMC). Nash and Hudson vehicles built after the 1955 merger were built on Nash bodies. Rambler eventually took over as the leading name for AMC.

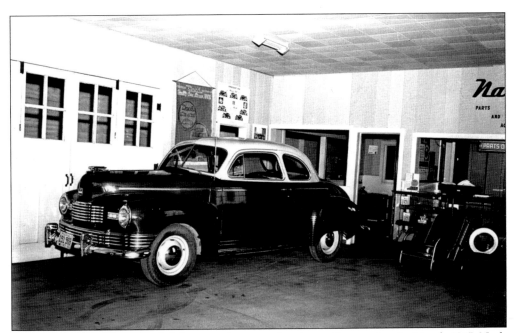

The inside of Anderson Nash Motors is shown at the time of its opening in March 1947. Nash Motors was founded in 1916 by former General Motors executive Charles W. Nash. Nash enjoyed decades of success by marketing mid-priced cars for middle-class buyers. Nash's slogan was "Give the customer more than he paid for."

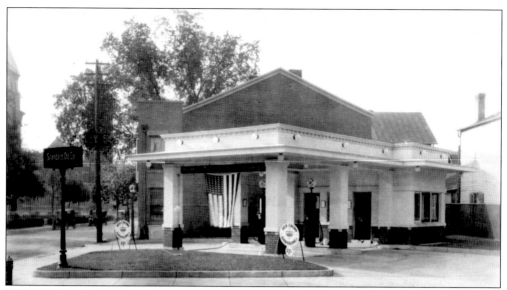

This is a Standard service station at Fourth and Busseron Streets around 1920. By 1910, oil companies began building larger stations resembling small houses. Shell and Standard Oil painted logos on their buildings as advertising, and brand names were developed. Standardized stations originated in 1914 with Standard Oil. In the 1920s, canopies were added to protect customers from sun and rain.

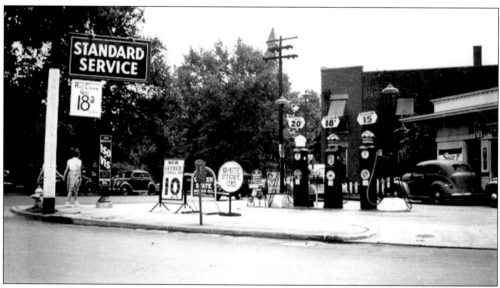

The Standard station at Fourth and Busseron Streets underwent a transformation with the removal of the protective canopy in the 1930s in order to accommodate larger automobiles on the small lot. Different grades of gasoline evolved as automobiles became more sophisticated. Standard Oil offered Stanolind as price leader, Red Crown at mid-level, and Ethyl as premium grade.

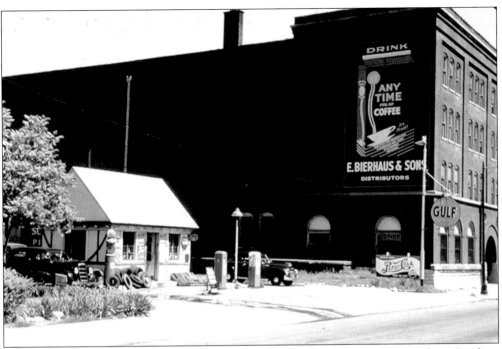

In this 1950 photograph, the cottage gas station can be seen. Behind it is Bierhaus Brothers Wholesale Grocery Warehouse, at Second and Perry Streets. This station, built in 1931 by White Way Gasoline Company, exhibits a trend of gasoline stations to resemble English cottages. It was operated as a Gulf station by Eugene Dicus before it was torn down in 1954.

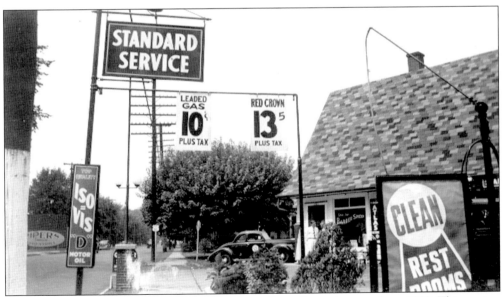

The Standard station on Washington Avenue at State Street is seen about 1939. This station was operated by Gaynold Martin and shared the English cottage–style building with the Wilkes Barber Shop, while the Lewis "Dick" Garage occupied the back. It was a one-stop shopping center: one could have a car fueled and repaired while getting a haircut. Note the gasoline prices of 10¢ and 13¢ per gallon.

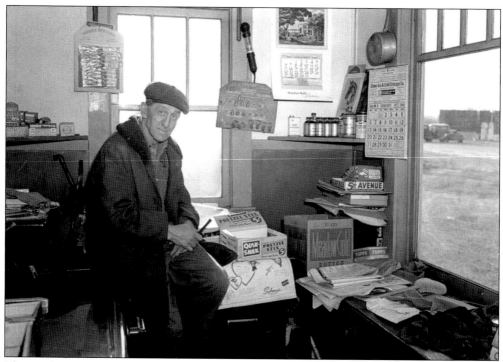

This is the Herman Mahrenholz Gas Station in 1946. At this one-man operation, Herman Mahrenholz would fill up the tank, wash the windows, and check the oil. This is a good example of the interior of a small filling station, offering an assortment of automobile accessories, motor oil, and oil additives, as well as candy and soda pop—a precursor to today's convenience stores.

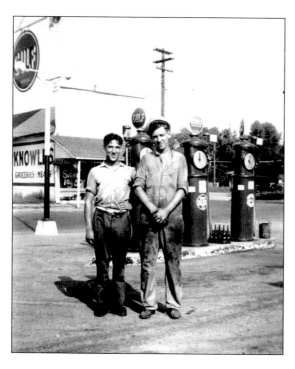

At Eleventh and Main Streets, the Old Post Auto Service Gulf filling station was located across Main Street from Knowles Grocery. This photograph from about 1935 shows two Old Post attendants ready for service. The Gulf Refining Company bulk plant was located behind the service station.

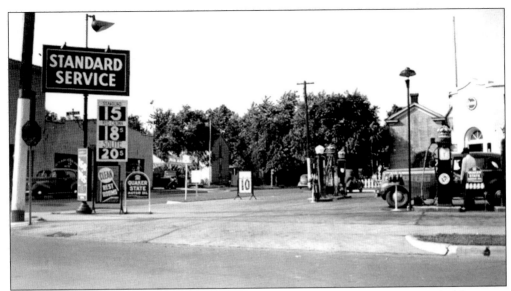

Around 1940, the Standard service station, at Sixth and Vigo Streets, was in an ideal location: the junction of Highways 41 and 50. This Standard Red Crown station was constructed in the late 1920s with a distinctive white glazed brick and a red tile roof. The station was torn down about 1960 to make way for the Doss Standard Super Service Center, consolidating all the other Standard stations in town.

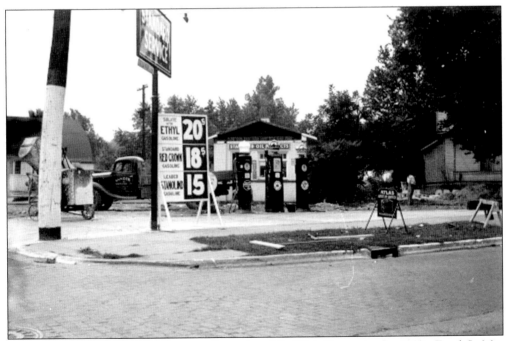

This is the Standard service station at Second and St. Clair Streets in the 1940s. Frank LaMar was the proprietor. Standard Oil Company had a dominant presence in Vincennes, operating as many as eight stations in 1935. In this photograph, Second Street is still paved in brick, and the Church of Christ building, still standing today, can be seen in the left background.

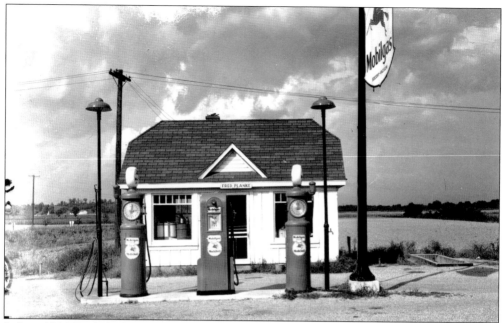

In June 1944, Fred Planke's Mobil gas station was located on the flat prairie in Westport, Illinois, near the junction of Highways 33 and 50. The station was built in the English cottage style, with a small pediment above the door and clipped gables.

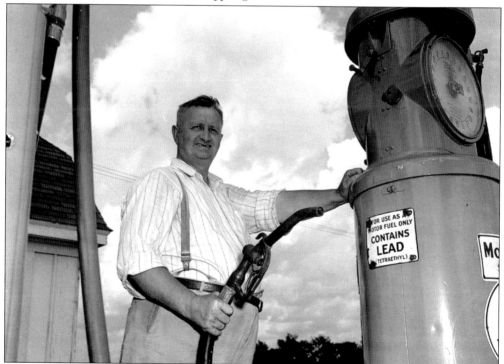

Fred Planke is seen here at his pump in June 1944. Later, in the 1950s, he moved to the other side of Highway 50 and had the service station at the popular B&L Restaurant, known for its chicken-in-the-basket Sunday dinners and Jim Beamon's French dressing.

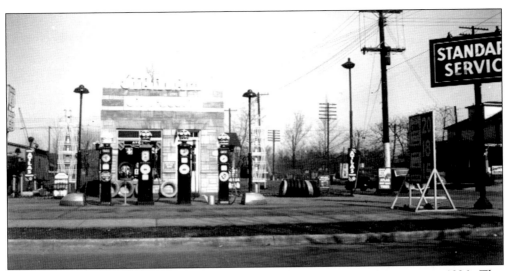

This is the Standard service station at Sixth Street and College Avenue in 1936. This art deco–style station was built of Indiana ashlar limestone, with a carved stone sign that reads "Standard Oil Products." Robert Ritterskamp operated this station for 28 years.

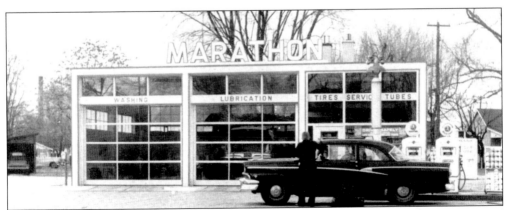

Robert Ritterskamp moved to a new location on Washington Avenue in 1956 and changed brands to Marathon. The new Marathon service station, seen here in 1957, is done in the International style of architecture, with its emphasis on large glass walls. For many years, Ritterskamp was also a well-known bus driver for Vincennes schools.

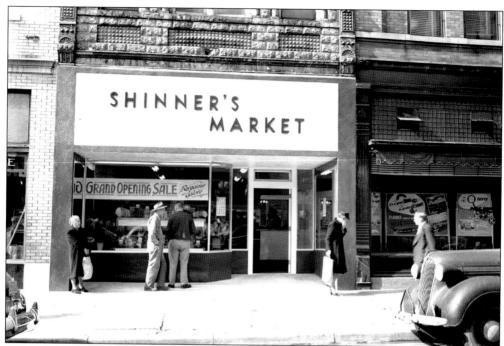

Shinner's Market, at 417 Main Street, is pictured on October 2, 1947. It was one of many neighborhood groceries scattered through the town. In the war years, with gas rationing, the stores were within convenient walking distance. Small groceries continued into the 1960s, but the emergence of large chain supermarkets and increased reliance on the automobile wiped most of them out in the 1970s.

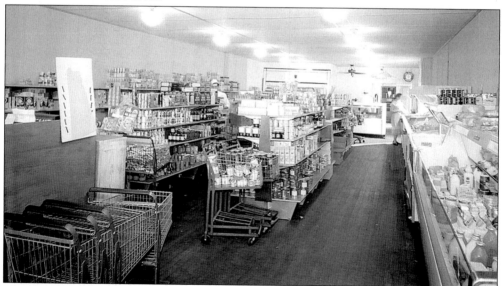

This photograph shows the inside of Piper's Supermarket, at Tenth and Main Streets, sometime in the 1940s. Local stores stocked a lot of local brands including Bierhaus Brothers' Scout Cabin and Fort Sackville brands. Dyers Packing Company's Alice of Old Vincennes ketchup, tomato juice, and chili sauce were big sellers. G. W. Imle's vinegar, mustard, and pickles were also popular.

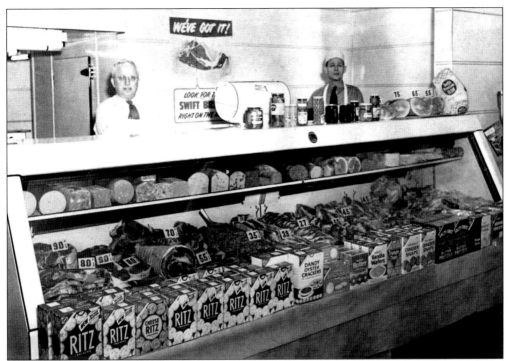

Haartje's Market, on Washington Avenue, was noted for its meat counter. A good butcher could get the most out of cuts of meat. This was important during the war because of meat rationing.

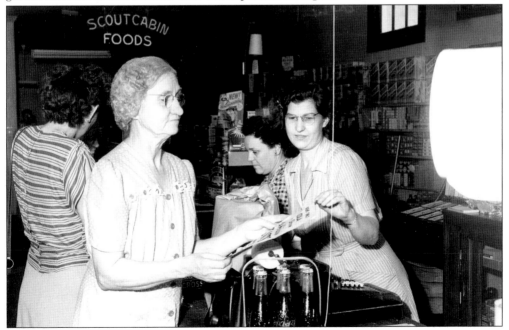

In Haartje's Market in June 1947, locally bottled Pepsi-Cola was prominent, no doubt because of citywide publicity for the Pepsi Variety Show at the Pantheon Theatre. Many products were kept behind the counter, and customers would bring a list for the grocer to fill. Scout Cabin brand foods can be seen in the background.

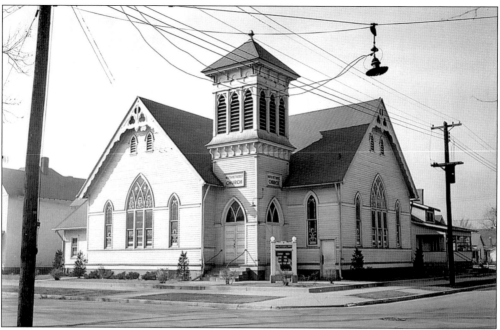

This is Northside United Methodist Church, at First and Sycamore Streets, in March 1945. Built in Gothic Revival style in 1905, the church expanded under the leadership of Rev. Frank Little from 1941 to 1952, with an educational unit, chapel, and gymnasium. In 1951, the church was given an ashlar veneer. The congregation moved to Hart Street Road after Vincennes University bought the church building for campus expansion.

The First Church of the Nazarene was built at the corner of Twelfth and Broadway Streets in 1918 under the leadership of Rev. U. T. Harding. In 1963, the congregation moved to a new church at Nineteenth and Main Streets. The old church was taken over by the congregation of Calvary Baptist Church.

In 1903, work began on the First Christian Church, at Third and Broadway Streets, shown here in 1916. It was built in an unusual Spanish Renaissance style, with Moorish arches. Revivals were common, with sermons such as "The Fall of Babylon" or "When the Devil Comes to Church." The church was damaged on March 3, 1962, when Boberg Garage burned down, and it was replaced with a new church in 1978.

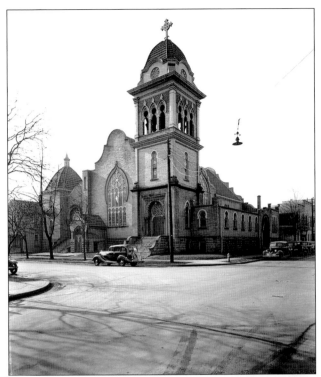

Reel Avenue Christian Church was built at the corner of First Street and Reel Avenue and was dedicated in 1914. It was one of the early congregations on the north side of town. The church moved to a new building on Franklin Heights in 1976, and the old church was torn down to make a tennis court for Tecumseh-Harrison Elementary School.

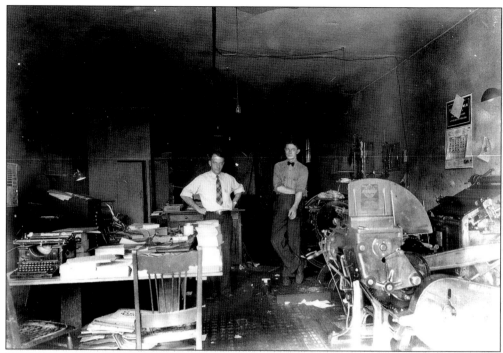

Ralph Winstanley Printing Company is seen in this 1936 photograph. It later became Vincent Printing and moved to Tenth and Hart Streets. Over the years, Vincennes supported many fine printers, including Ewing, Kramac, Petts, Crotts, Green, and Hitt.

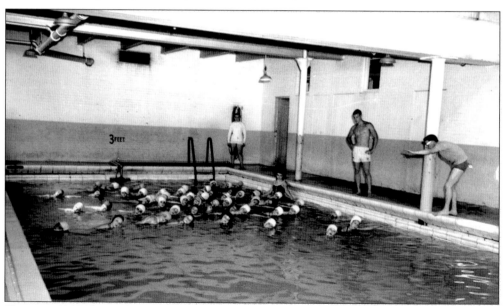

Shown in 1960, the pool is full of young people learning how to use the scuba at the YMCA. The Y opened at Fourth and Broadway Streets in 1913. To divert youths from the "lurid attractions" of movies and pool halls, it had a 60-by-21-foot pool, a billiard table, a gymnasium, and 40 rooms for male boarders. Thousands of children learned to swim at the Y pool, which had a balcony so parents could watch.

Three

SPECIAL EVENTS

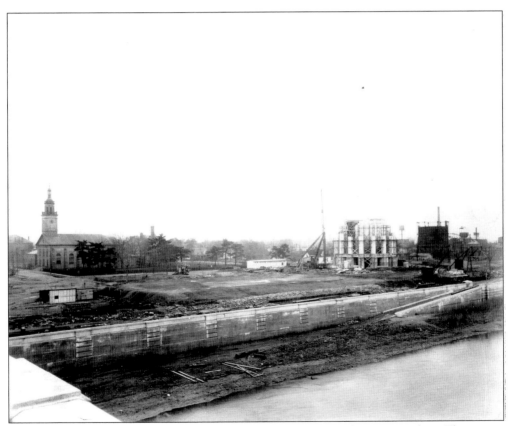

On May 19, 1932, columns around George Rogers Clark Memorial are put in place. The view is from the nearly complete Memorial Bridge. Old Cathedral is to the far left, the Central States Gas storage tank to the right, and the seawall in the foreground.

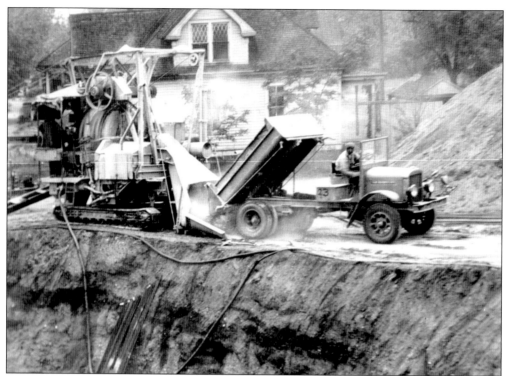

In September 1932, construction of the memorial begins. A giant pit is dug at First and Barnett Streets. On October 13, work began on the foundation. Gravel was supplied by Lenahans and Konen trucks. Two mixers continuously poured concrete into forms.

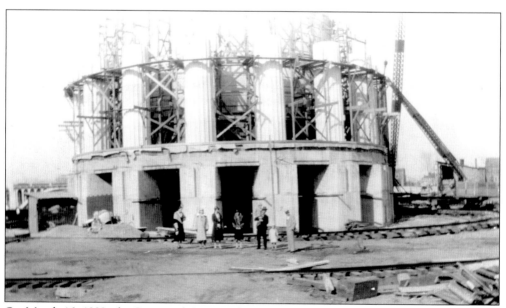

On March 16, 1932, the Stanstead Granite drums of the Doric columns were brought in next to the memorial by railroad flatcars and lifted into place by a 90-foot steam crane. Each granite drum was 6 feet 4 inches in diameter and weighed 10 tons.

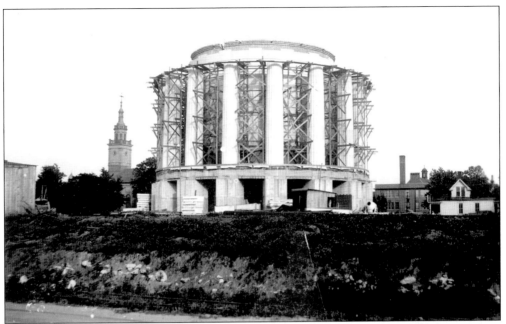

On June 2, 1932, the last of 148 granite drums is put in place, surrounding the memorial with 16 Doric columns, each weighing 98 tons. Work then began on placing the entablature and pouring the dome. The superstructure was done on October 3.

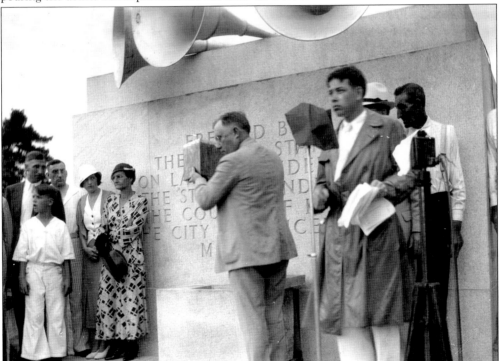

The memorial's cornerstone is put in place on September 3, 1933, the 150th anniversary of the Treaty of Paris that ended the Revolutionary War. D. Frank Culbertson (center), chairman of the Memorial Commission Executive Committee, presides.

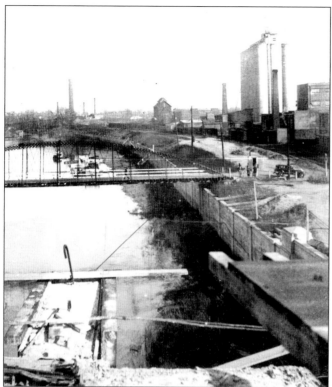

The Memorial Bridge was still under construction on December 29, 1931, when this photograph was taken. The photograph shows the Vincennes riverfront, old Main Street Bridge, and the recently completed concrete seawall, which was 1,000 feet long and 23 feet high.

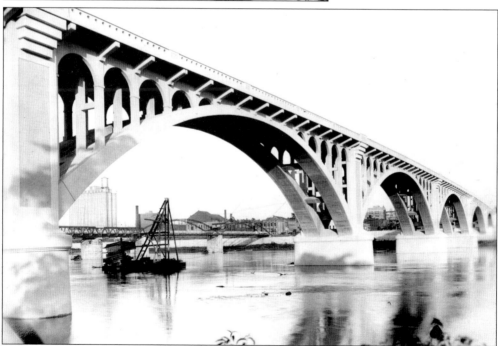

The new bridge was completed in 1933 and was named Lincoln Memorial Bridge in recognition that Abraham Lincoln and his family had taken a ferry across the Wabash River at this point in March 1830, as they moved from Indiana to Illinois.

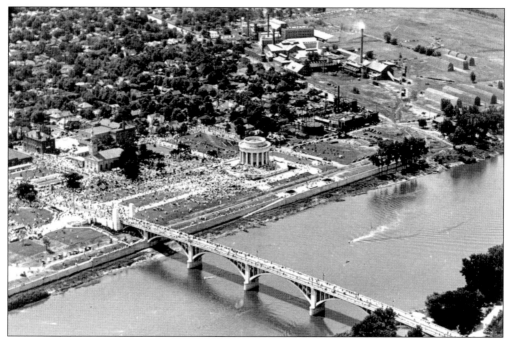

A crowd of 75,000 gathers to witness the dedication of the George Rogers Clark Memorial on June 14, 1936. This Associated Press aerial photograph shows the crowd assembling on the Memorial Esplanade.

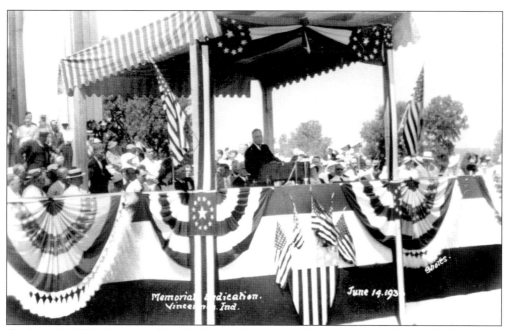

On June 14, 1936, Pres. Franklin D. Roosevelt, speaking from a bunting-decorated platform in front of the memorial, proclaims George Rogers Clark's campaign "a brilliant masterpiece of military strategy."

Grouseland was the home of Indiana Territory governor William Henry Harrison (later president) from 1804 to 1812. This photograph shows the home around 1890, before restoration, when it is still a residence.

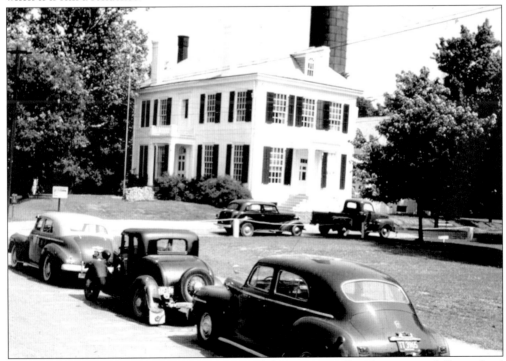

In 1909, the Francis Vigo Chapter, Daughters of the American Revolution, saved Grouseland from demolition. In this 1950 photograph, the house is painted white, and the front portico has not yet been restored. The standpipe behind it was taken down later that year.

In 1933, the Women's Fortnightly Club restored the old Indiana Territory capitol at Parke Street, between Hickman Street and Indianapolis Avenue. Built in 1805, the small two-story frame building was used by the legislature in 1811. It originally stood on Main Street and was later moved to North Third Street, where it was rescued in 1919 by the Fortnightly Club.

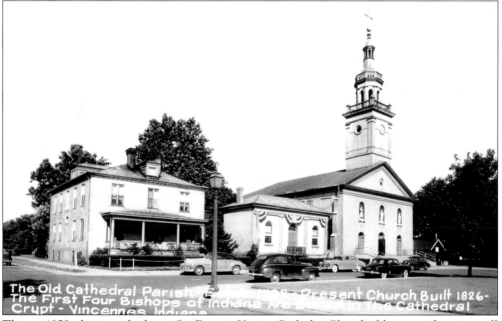

This c. 1950 photograph shows St. Francis Xavier Catholic Church, library, and rectory, all painted grey. Parish records began in 1749. The present church, built in 1826, was the cathedral of the Diocese of Vincennes from 1834 to 1877, hence the name Old Cathedral.

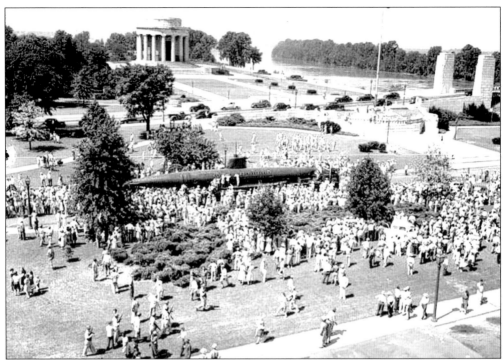

On August 11, 1943, an 81-foot Japanese two-man submarine, captured during the attack on Pearl Harbor, was put on display at Patrick Henry Drive as part of a war bond drive. The only survivor of 10 men in five submarines that made the attack, submarine commander Ens. Kazuo Sakamaki became U.S. prisoner of war No. 1.

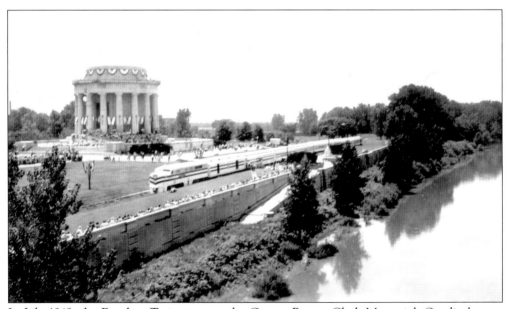

In July 1948, the Freedom Train stops at the George Rogers Clark Memorial. On display are Thomas Jefferson's original draft of the Declaration of Independence, manuscript copies of the Constitution and Bill of Rights, and other historical memorabilia.

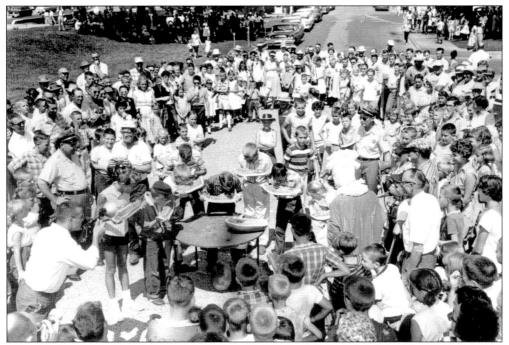

In August 1958, the second annual Watermelon Festival was in full swing on Patrick Henry Drive, with melon-eating (shown) and seed-spitting contests, a watermelon queen, fireworks, a water show, an air show, and thousands of free watermelon slices.

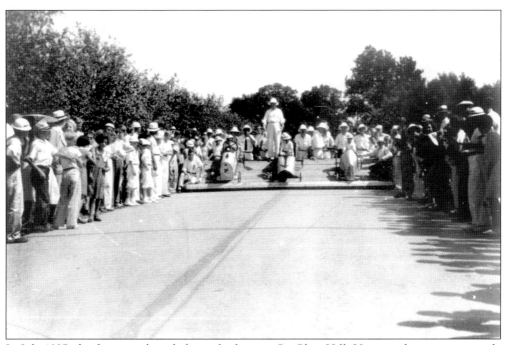

In July 1935, the first soap box derby took place on St. Clair Hill. Homemade cars, some made from soap boxes, raced down the hill before 10,000 spectators. Billie Cooper won the race. The race was held only one more time, in 1936. (Bob Mays collection.)

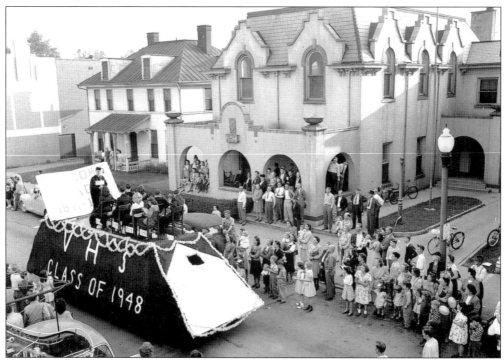

The high school homecoming parade is a beloved Vincennes tradition. Every September, on the occasion of the first home football game, alumni from far and near gather to renew old friendships and reminisce. This is a float from the 1948 parade.

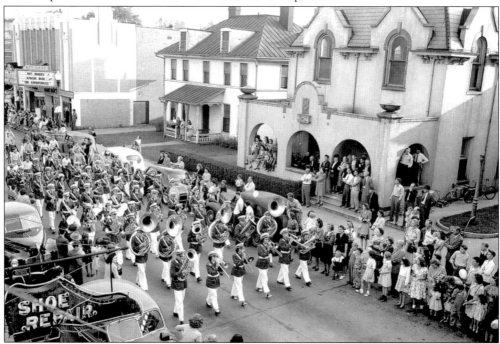

The Lincoln High School band marches past Knights of Columbus Hall, on Main Street, between Fifth and Sixth Streets, during the 1948 homecoming parade.

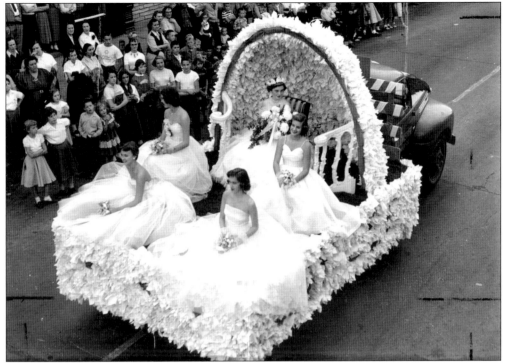

The 1953 homecoming queen, Valerie Jordan (now Sweeney), and her court are featured on this float as it passes in front of Hoosier Supply at Fifth and Main Streets.

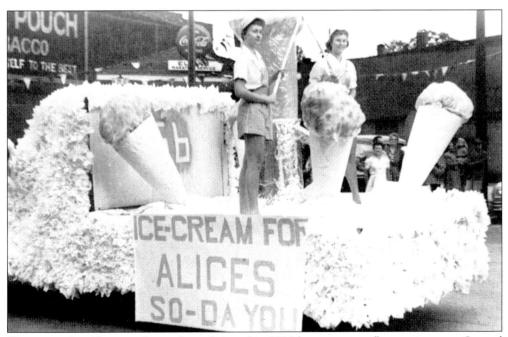

"Ice-cream for Alices so-da you," proclaims this 1956 homecoming float as it passes Second and Broadway Streets. "Alices," the nickname for the Vincennes team, comes from the 1901 best-selling novel *Alice of Old Vincennes* by Maurice Thompson.

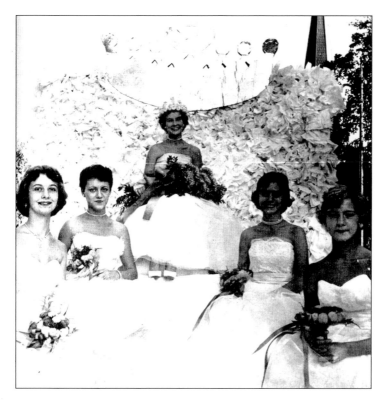

Lincoln High homecoming queen, Flossie Hartsock, presides over her court on this 1956 float.

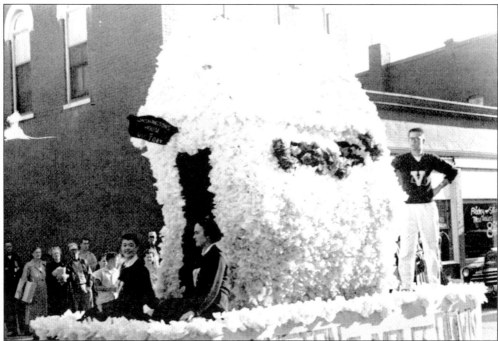

Lincoln cheerleaders in 1956 ride a float made by the boosters club. Float making was serious business. Every class and club spent weeks constructing frameworks of wood and chicken wire on flatbeds and then stuffed them with thousands of paper napkins.

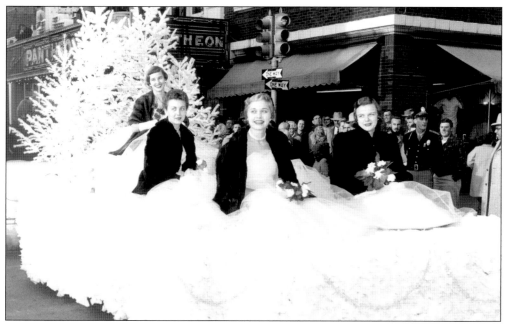

On December 1, 1956, Vincennes University's homecoming parade celebrated the sesquicentennial of the university's founding in 1806. This float featured 1956 Vincennes University homecoming queen, Mollie Jordan (now Davidson), and her court. (Chester Gates photograph.)

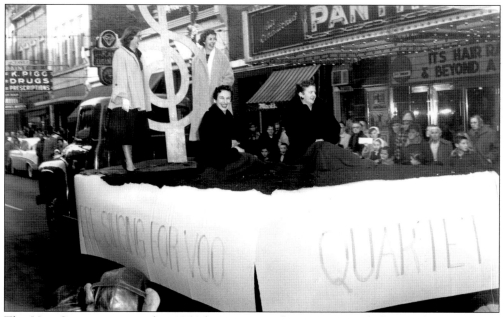

The Voo Quartet was on this 1956 homecoming float as it passed the Pantheon Theatre. The sign on the float reads, "We're singing for Voo." "Voo" was the nickname for Vincennes University. (Chester Gates photograph.)

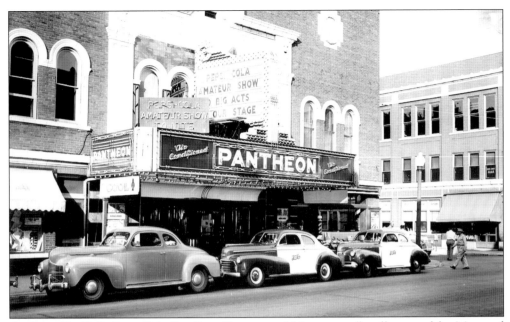

On June 20, 1947, Pepsi-Cola Bottling Company of Vincennes (locally owned by Max and Charles Shircliff) sponsored an amateur talent show at the Pantheon Theatre, featuring "10 big acts of hometown talent." (Bill Offutt photograph.)

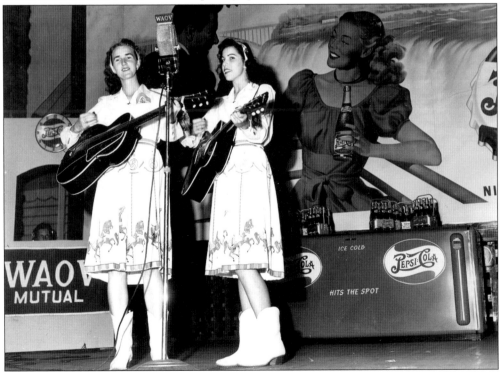

Onstage at the Pantheon, country western singers Frances Wright and Goldie Mallott perform in the Pepsi-Cola Amateur Talent Show. The program was carried live by local radio station WAOV (standing for Alice of Old Vincennes). (Bill Offutt photograph.)

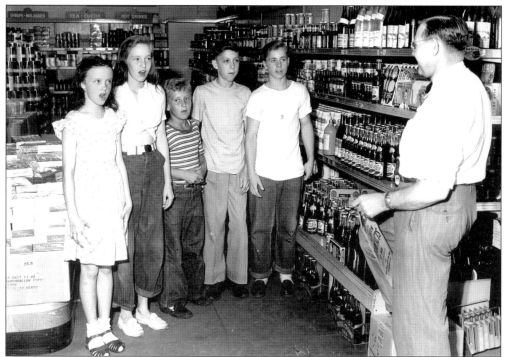

A quintet of young singers tries out in a local grocery for the June 20, 1947, Pepsi-Cola Amateur Talent Show. They are no doubt singing that popular ditty "Pepsi-Cola hits the spot / Twelve full ounces, that's a lot / Twice as much for a nickel too / Pepsi-Cola is the drink for you." (Bill Offutt photograph.)

Ebner Ice Company opened Double Cola bottling works at First and Busseron Streets in 1939. It featured a hostess center with an experimental kitchen on the second floor, shown here in March 1942, in which housewives learned to make various party treats.

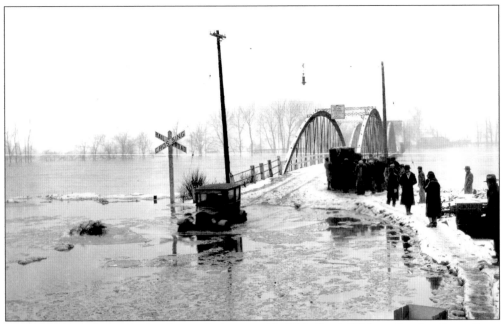

This is the Main Street Bridge during the January 13, 1930, flood. With no flood wall, sandbags alone held back the water. The river reached 25.7 feet, but a –12 degrees temperature froze the sandbags rock solid and saved the city.

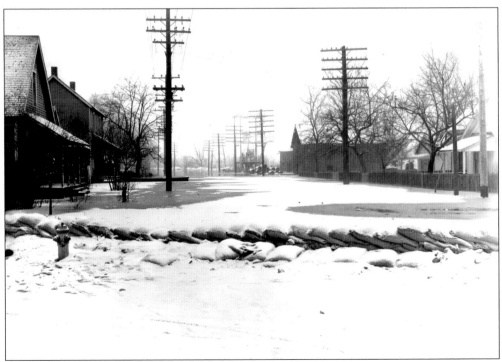

Sandbags line First Street in the 1930 flood. The view is down Seminary Street, looking west toward the river. The Baltimore and Ohio Railroad bridge can be seen faintly through the fog in the distance.

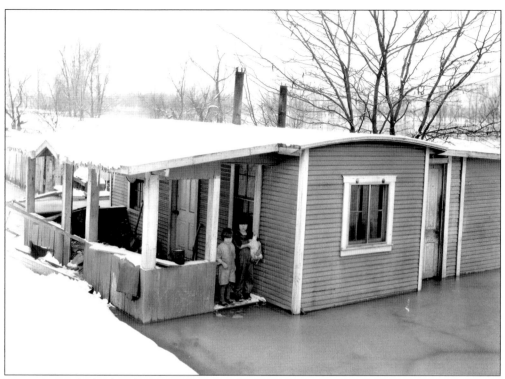

Two young girls display their pet rooster on the porch of their house (or is it a houseboat?) next to the levee in Pearl City, below Willow Street, in the January 1930 flood.

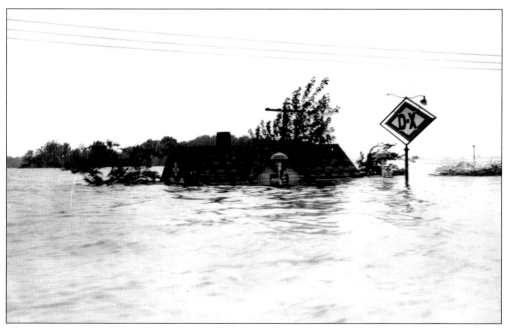

The 1943 flood reached a dangerous stage of 28.99 feet on May 23. The levee on the Illinois side broke in two places and flooded Westport, including this D-X gas station. Army amphibious jeeps were used for search and rescue.

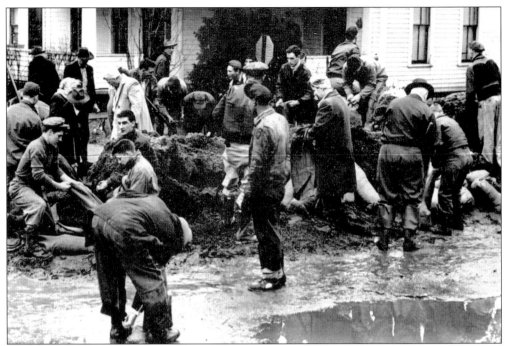

In January 1950, the Wabash crested at 28.6 feet. National Guardsmen, the Red Cross, the Salvation Army, firemen, citizens, housewives, and Vincennes University and high school students filled 350,000 burlap bags with sand and piled them for two miles along the river.

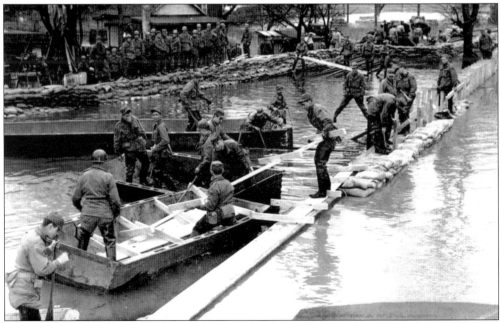

During the 1950 flood, army engineers from Louisville directed the construction of mud boxes atop the flood wall near Kimmell Park. The park flooded so often after it opened in 1938 local wags dubbed it "Swimmell Park."

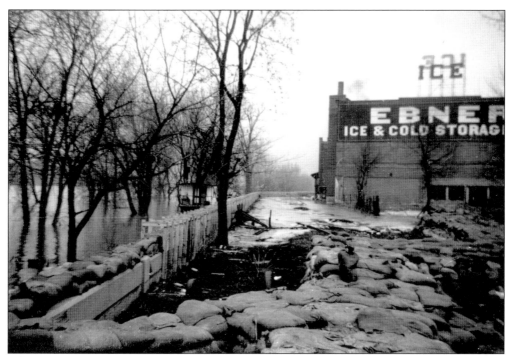

Behind the Ebner Ice and Cold Storage building (now Vincennes University's technology building), sandbags shored up the flood wall as it threatened to fail in the 1950 flood. Seriously weakened in the 1943 flood, the flood wall was never wholly repaired.

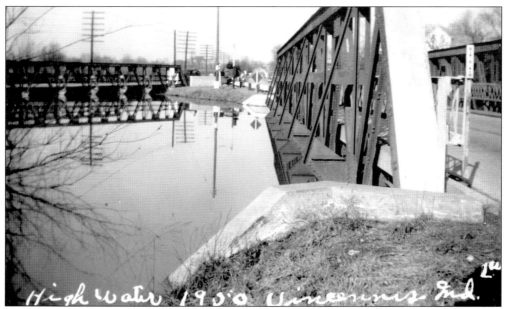

The old Highway 67 and Highway 41 bridges north of town were inundated by Kelso Creek in the 1950 flood. After two tense weeks, the Illinois levee broke, relieving pressure on Vincennes. Afterward Illinois residents claimed the levees were dynamited.

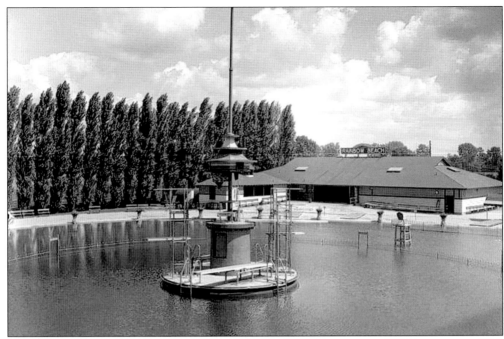

Rainbow Beach opened in 1937. Built as a Public Works Administration (PWA) project in 1936, Rainbow Beach had an innovative circular design and a central island with diving boards. An overhead sprinkler made a rainbow when the lights shined on it. Later four waterslides were added.

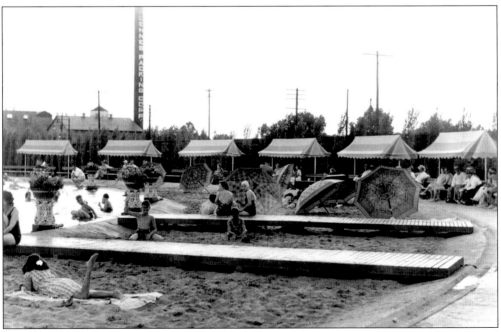

Rainbow Beach featured a sand beach around the pool, on which children could build sand castles and sunbathers could stretch out on blankets. Beyond, canvas tents sheltered spectators. Rainbow Beach was replaced in 1971 by an Olympic-style pool, also called Rainbow Beach, which had no rainbow and no beach.

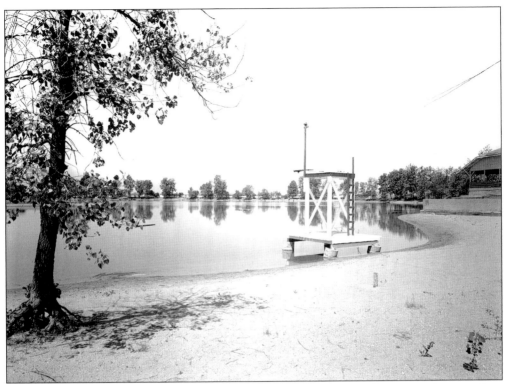

Lake Lawrence, northeast of Lawrenceville, Illinois, has been a favorite gathering place for Vincennes residents to swim, boat, and party since the 1920s. This photograph is from May 14, 1941.

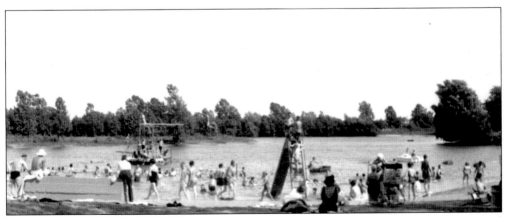

Mirror Lake, at Seventeenth and Hart Streets, had a grand opening on May 22, 1955. Lee and Lou Moore operated it as a popular swimming hole until about 1970, when it became a housing development. In the 1800s, it was Marais du Cochon, or "Hog Swamp." In the 1930s, it was a gravel pit.

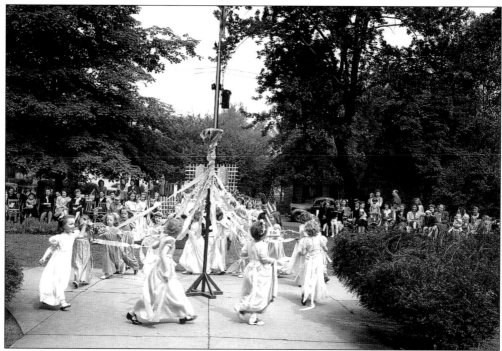

On May 1, 1946, children at LaSalle School, at Seventh and Barnett Streets, celebrate May Day, the first day of spring, by dancing around a Maypole while holding colored streamers. A May queen was selected and crowned by a Prince Charming. This old English custom was popular in local schools from the 1890s into the 1940s.

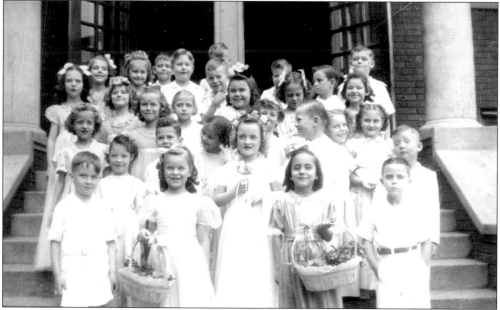

This is the Clark Grade School May Day queen and court in 1945. Clark Junior High School, at Sixth and Perry Streets, also had a grade school at this time. Try to spot William Hopper, one of the authors of this book.

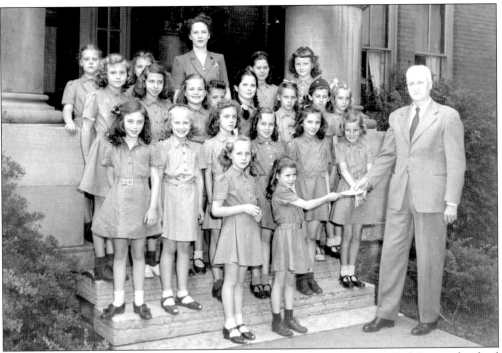

In front of old Vincennes University in 1946, Pres. Walter A. Davis gives Girl Scouts the deed to Camp Wildwood, on Washington Avenue. Vincennes University bought Flint Hill in 1923 for a new, roomier campus (with streetcar service) but later changed its plans.

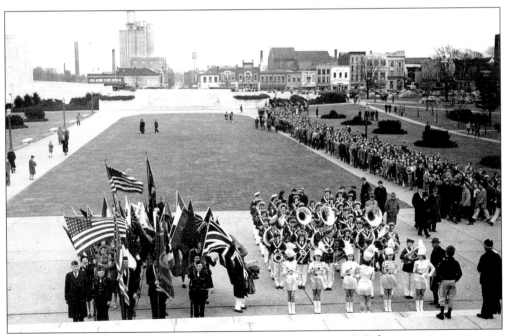

A color guard and band assemble on the memorial steps in 1943 for a patriotic program, perhaps Flag Day or a war bond drive. Over the years, the memorial has witnessed hundreds of graduations, weddings, fireworks, and other civic events.

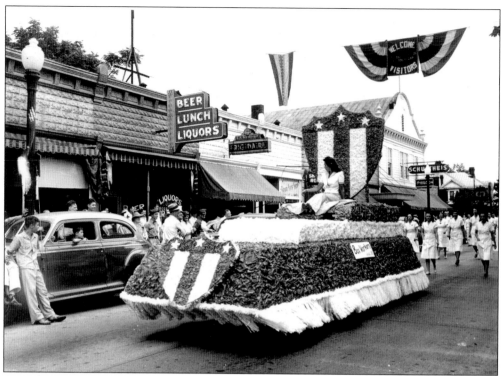

On Labor Day, September 1, 1941, the box workers' float passes Schultheis and Sons Furniture Store at Sixth and Main Streets. The workers were probably from Pomeroy's Corrugated Box Company. Afterward there were speeches by labor leaders and a carnival at Riverside Park.

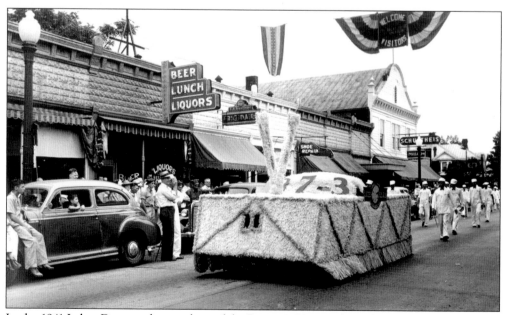

In the 1941 Labor Day parade, members of the Painter's Union, dressed in white, march behind a float decorated with a big V, which probably stands for victory. Although not yet at war, the country had begun the draft the year before and had started war production.

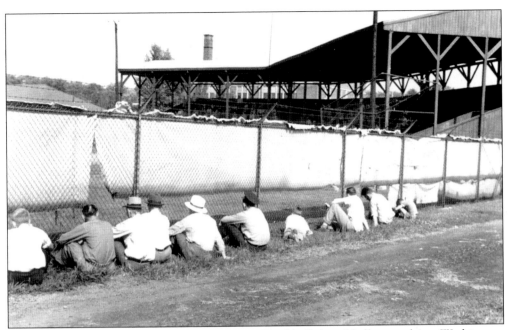

On July 6, 1941, spectators watch the Vincennes Double Cola softball team play at Washington (later Inman) Field. Note the old wooden stands. Photographer John Vachon documented daily life in Indiana for the Farm Security Administration.

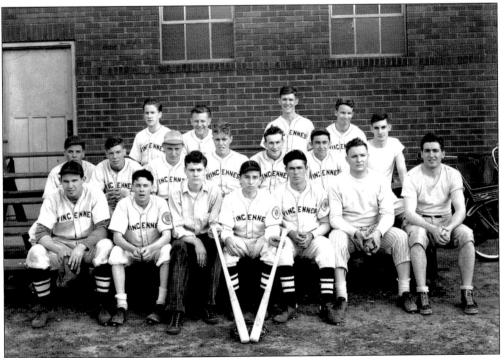

In May 1940, the Lincoln High School baseball team poses for a picture. The two baseball bats form a V for Vincennes. A few short years later, many of these boys were fighting in World War II.

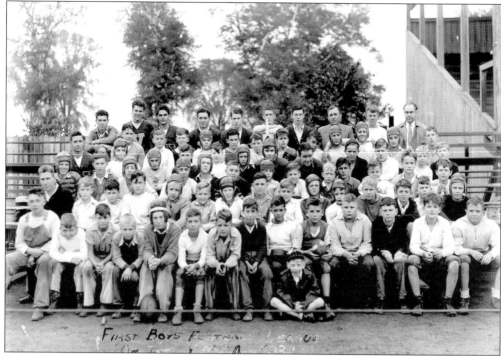

This is the first YMCA football league in 1934 at Washington Field. Note the wooden stands. In the back row are the coaches: members of the Lincoln High School team, Y director Ray Beless (far right), and Lincoln coach John L. Adams (third from right).

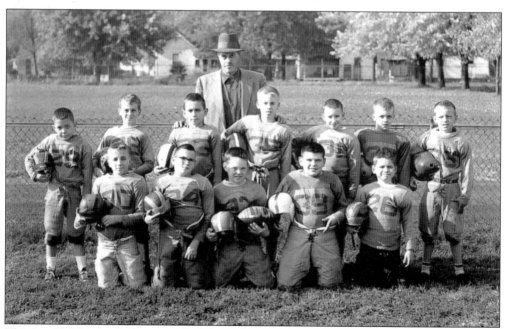

This is a YMCA football team called the Wildcats around 1955 at Inman Field. The coach is Enoch Olsen. The Wildcats played on Saturday mornings. The Y supplied equipment—shirts, helmets, and pads—to any boy who needed it.

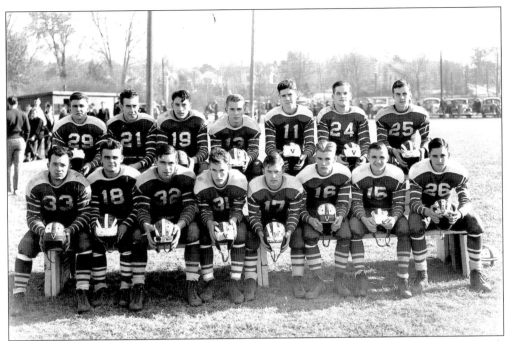

The Lincoln High School football team poses for a photograph in November 1938. Coach John L. Adams began a tradition of athletic leadership from 1920 to 1939. He was followed in the 1940s and 1950s by George Inman and, after 1957, by Ray Mills.

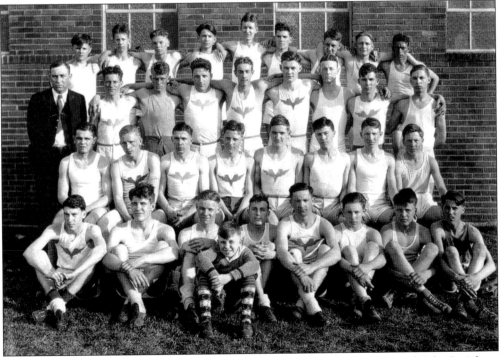

This is the Lincoln High School track team around 1939, with multitalented coach John L. Adams in the third row at the far left. George McCormack succeeded Adams as track coach in 1939.

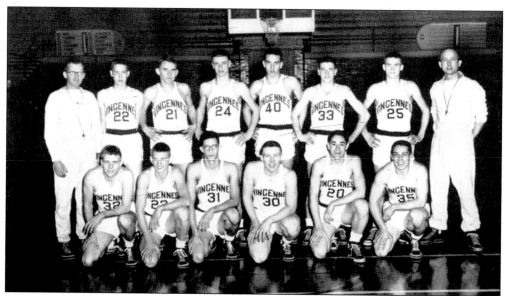

The 1954 Lincoln High School basketball team is part of an athletic heritage dating back to 1905. Lincoln has won more sectional championships than any other high school in Indiana, and the Alices have twice gone on to win state championships, in 1923 and 1981.

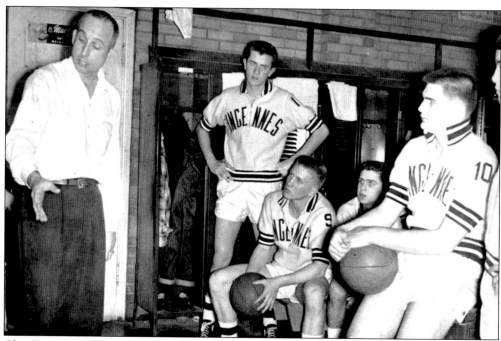

Chet Francis, in the locker room with the 1957 Lincoln team, coached for 10 years, winning 130 games and losing 116. He was a member of the 1940 Indiana University NCAA team. In 1986, he was inducted into the Indiana Basketball Hall of Fame.

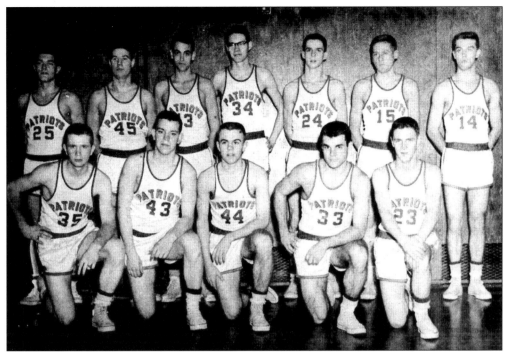

In 1955, the Vincennes Central Catholic High School varsity team was runner-up in the Wabash Valley basketball tournament. The Central Catholic (later Rivet) Patriots were always fierce competitors with the Lincoln Alices.

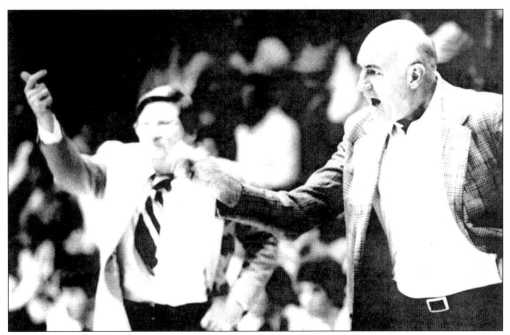

Legendary Central Catholic coach Ralph Holscher (right) is shown in 1955 in the heat of a game against Loogootee, with coach Jack Butcher. Holscher wrote a comment on this photograph: "Jack was coaching the officials. I was coaching my team. Guess who won?"

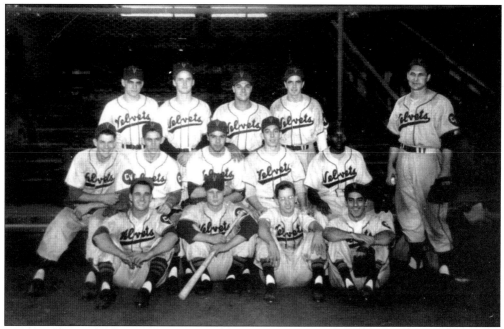

In 1950, the city's only professional baseball team, the Vincennes Velvets, poses at Nehi Park behind Nehi Bottling Works, at Thirteenth and Willow Streets. The team's name came from the sponsoring Terre Haute Brewing Company's Champagne Velvet beer.

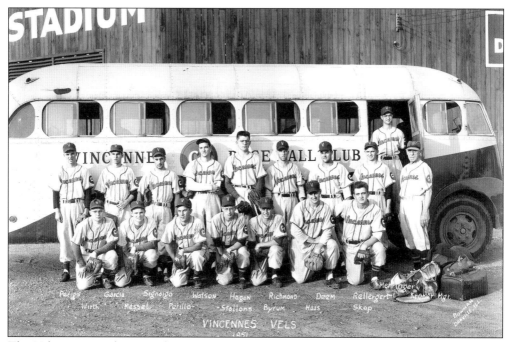

The Velvets are in their traveling uniforms in Danville, Illinois, on June 17, 1951, where they suffered their worst defeat 40-5. On the right is owner-manager George "Stormy" Cromer. Vincennes native Cy Deem is in the second row, third from the right. The Velvets played in the Mississippi-Ohio Valley Class D minor league from 1949 to 1952.

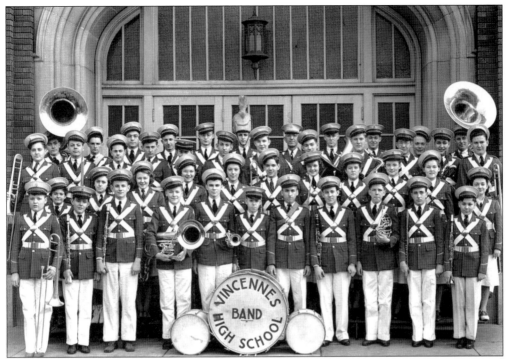

The Vincennes High School band stands in front of the old Lincoln High School, at Sixth and Buntin Streets, on February 17, 1939. The band director from 1924 to 1951 was Oscar L. Dunn, who also directed the high school orchestra.

Things are hopping at the Teen Canteen in the old John Hoffman Grocery at Second and Perry Streets in 1950. Inside are a jukebox, table tennis, checkers, dominoes, and canasta. The Teen Canteen was organized in 1945 by parents as a place for teenagers to go. Membership was $3 per year.

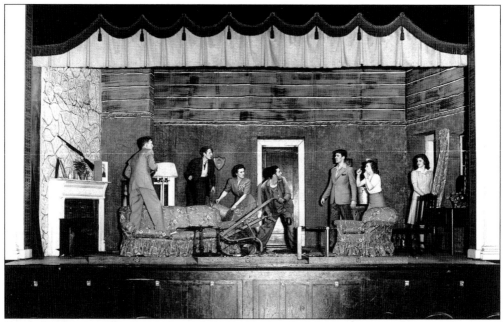

George Washington Slept Here, a comedy by George S. Kaufman and Moss Hart, is presented on April 22, 1942, on the stage at the Women's Fortnightly Club, at Sixth and Seminary Streets, by the Little Theatre company, which was organized in 1931.

On July 1, 1950, Vincennes celebrates the Indiana Territory sesquicentennial. A kangaroo court at Patrick Henry Drive punishes all who fail to grow beards with a paddling and ducking in a trough of cold water. Howard Greenlee (left), editor of the *Sun-Commercial*, is a victim, Robert Reel is judge, Robert McCormick is prosecutor, and Dan Bainum is bailiff.

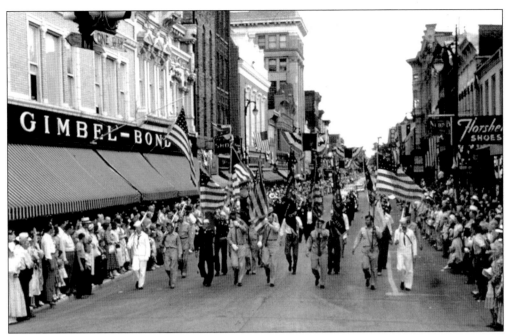

A color guard of servicemen leads the sesquicentennial parade in July 1950. The celebration was overshadowed by the start of the Korean War the week before. Many floats had a patriotic theme.

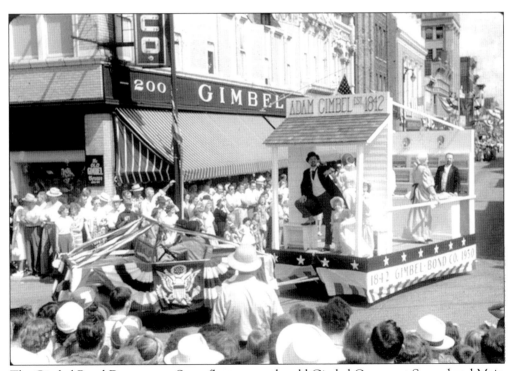

The Gimbel-Bond Department Store float passes the old Gimbel Corner, at Second and Main Streets, during the sesquicentennial parade. Gimbel's started in Vincennes in 1842. Note the pith helmet in the foreground—normal summer attire for city policemen.

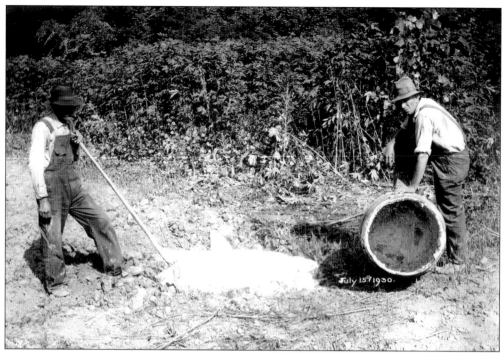

On July 15, 1930, a barrel of moonshine mash is disposed of in a cornfield near Vincennes. Sale of alcoholic beverages was illegal from 1920 to 1933. Some locals resorted to bootleggers for imported drinks, but many preferred to brew their own.

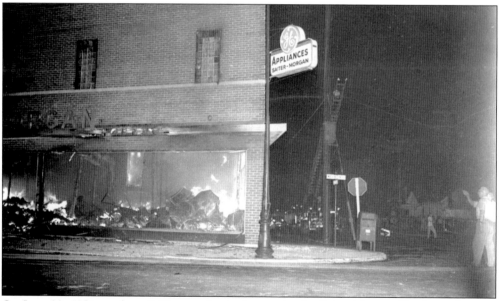

On June 20, 1954, at about 8:30 p.m., fire broke out in the Saiter-Morgan Hardware Store at Seventh Street and College Avenue. Cans of paint exploded, and clouds of sparks shot high into the night sky, thrilling onlookers—"the biggest crowd since Roosevelt came," it is said. Afterward there was a big fire sale. One of the authors bought a plastic model submarine, only slightly melted.

Four

WORLD WAR II

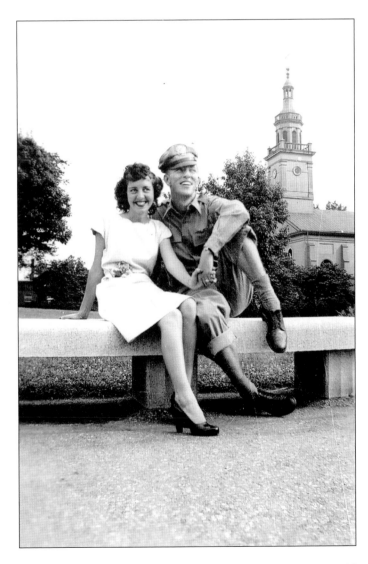

A U.S. Army Air Force cadet from nearby George Field and his girlfriend relax on a bench in front of the George Rogers Clark Memorial. The cadet's pants are rolled up, suggesting he has been wading in water while laying sandbags in the May 1943 flood. In the background is the spire of the Old Cathedral.

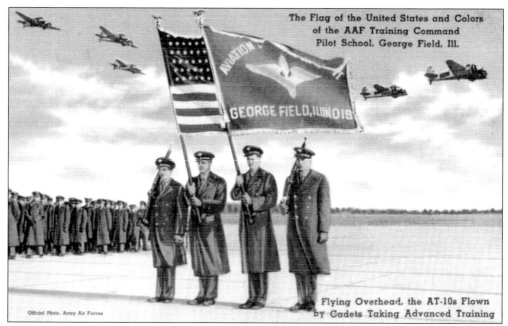

The Flag of the United States and Colors of the AAF Training Command Pilot School, George Field, Ill.

GEORGE FIELD, ILLINOIS

Official Photo. Army Air Forces

Flying Overhead, the AT-10s Flown by Cadets Taking Advanced Training

This postcard shows the color guard with the U.S. flag and colors of the U.S. Army Air Force Training Command Pilot School at dedication ceremonies on October 16, 1942, at George Field, Illinois, five miles west of Vincennes. Overhead fly AT-10 trainers.

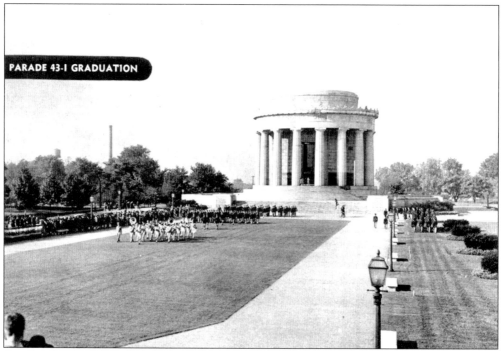

PARADE 43-I GRADUATION

On October 3, 1943, led by the George Field band, cadets of class 43-I parade past a reviewing stand at the George Rogers Clark Memorial. They received silver wings in a ceremony at the Coliseum. The 18 other classes graduated at the post theater, the last of them on August 4, 1944.

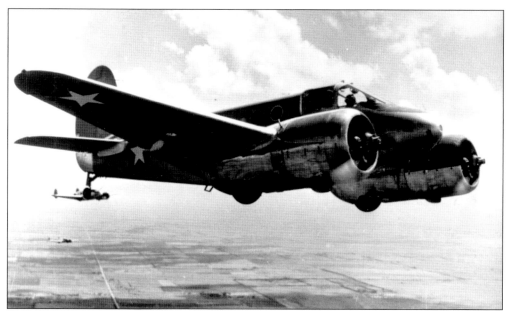

The airplane used at George Field for advanced training from 1942 to 1944 was the twin-engine Beachcraft AT-10 Wichita. To conserve valuable metal, it was built mostly of plywood, except for the engine cowls and cockpit. It had a wingspan of 44 feet, a length of 34 feet, and a top speed of 198 miles per hour.

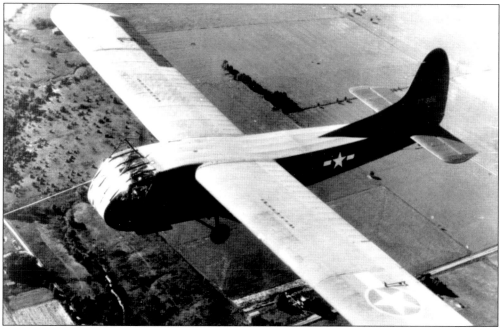

On September 1, 1944, the U.S. Army Troop Carrier Command took over George Field. Soldiers were taught to fly the CG-4A Waco glider, which was built of wood and metal framework and covered with fabric. It had a pilot and copilot, and it could hold 13 soldiers or a jeep or a howitzer, loaded through the upward-hinged nose. It was towed at a top speed of 150 miles per hour behind a twin-engine C-47 Skytrain or larger C-46 Commando.

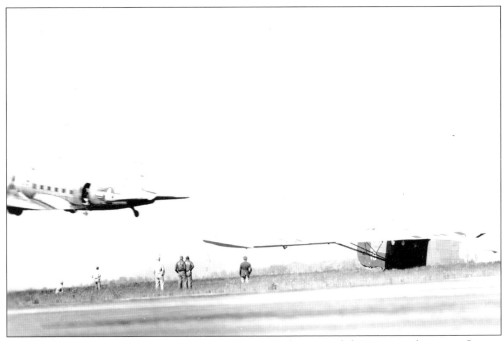

A C-47 demonstrates a flyby snatch of a glider from the ground during open house at George Field on May 5, 1945. There was also a mass jump of 100 paratroopers from C-47s and C-46s. Afterward 50,000 visitors experienced a monumental traffic jam, as 10,000 automobiles tried to exit the field on a few narrow roads.

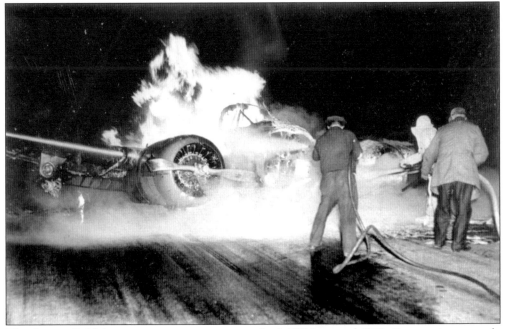

The George Field fire crew pours water on a crashed AT-10 around 1943. Because it was made mostly of plywood, the airplane would burn quickly, and after an accident, the crew of two had to get out fast.

On October 14, 1942, the United Service Organizations (USO) rented the former Harry Simpson house, at 502 Broadway Street, as a club for aviation cadets from George Field. Built in 1909 for Rush Bond, the stately house is now privately owned.

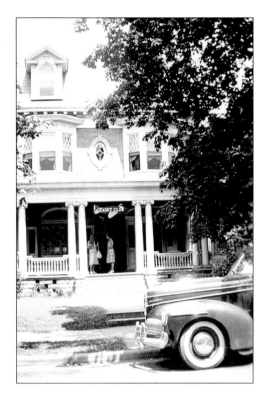

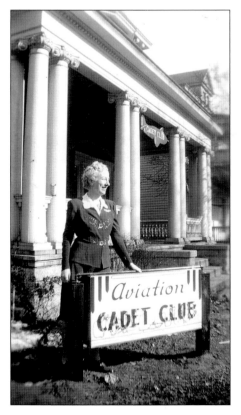

Merle Cornoyer, called Mom by the cadets, stands in front of the Aviation Cadet Club. As hostess, she organized activities, chaperoned dances, and counseled lonely flyers. In the absence of a wife or sweetheart, she pinned the silver wings on graduates and afterward saw them off at the train depot with a hug and a kiss.

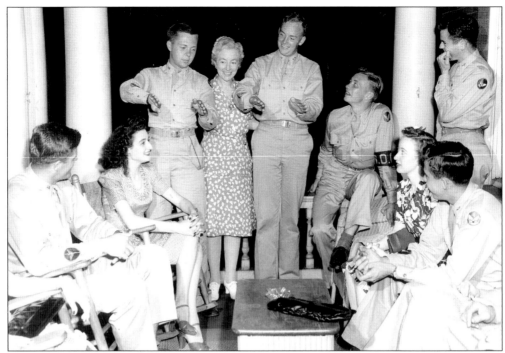

On the front porch of the Cadet Club, aviation cadets use their hands to demonstrate aerial combat to Mom Cornoyer and admiring young women. Local girls helping at the USO were called Alices, after the heroine of the popular novel. Although dating was forbidden, some local girls married cadets as a result of USO romances.

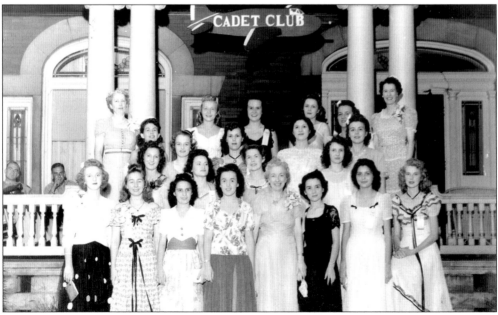

Debutantes stand in front of the Cadet Club in 1943. A ballroom on the third floor held 50 couples. The second floor had a room for the hostess and two recreation rooms. The first floor had a lounge with a radio and phonograph. The basement had a bar.

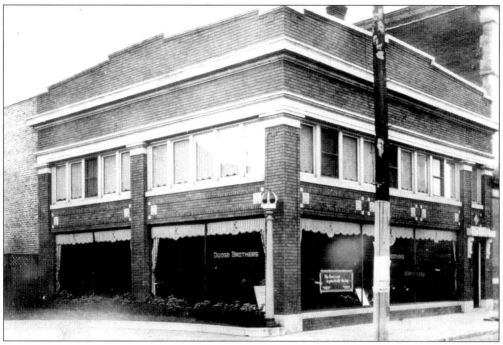

Built in 1919, the Kixmiller Dodge automobile showroom, at 19 North Fourth Street, was converted in 1943 into a USO canteen for enlisted servicemen. In the old Dunbar School, at Twelfth and Seminary Streets, there was a separate canteen for African American servicemen.

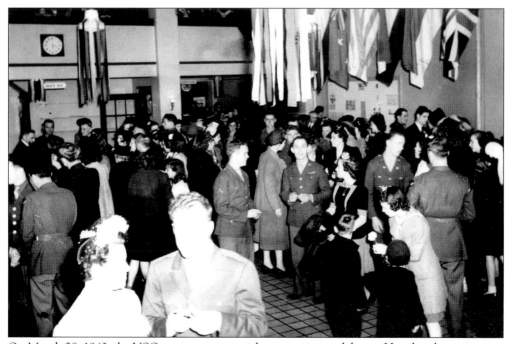

On March 28, 1943, the USO canteen opens with a reception and dance. Here lonely servicemen could meet local girls for dancing, cards, checkers, and talk. The canteen was also headquarters for the flood fights of 1943 and 1950.

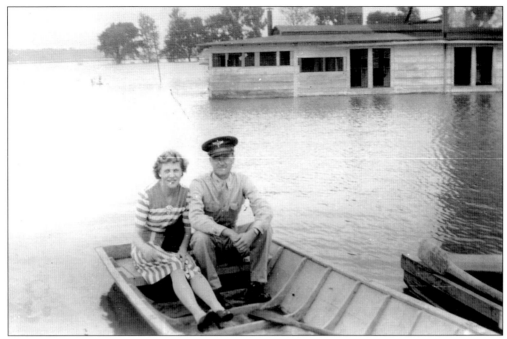

A George Field cadet and his girlfriend sit in a boat just across the Memorial Bridge, in Westport, during the May 1943 flood. The flooded Showboat Tavern is in the background. The Showboat, when not underwater, was a popular place to dance and listen to jazz. Hostess Betty Welton could do a great imitation of Sophie Tucker.

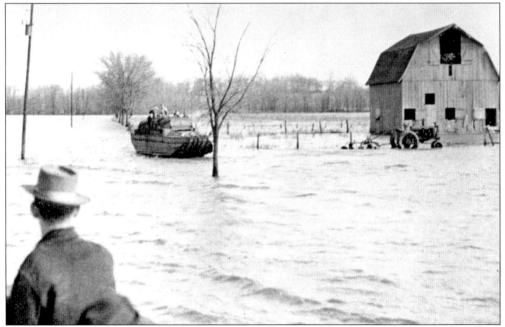

A National Guard duck (amphibious vehicle) swims past an inundated Illinois barn during the flood of January 1950. The river reached 28.6 feet before the levee broke on the Illinois side, relieving pressure. (Bill Offutt photograph.)

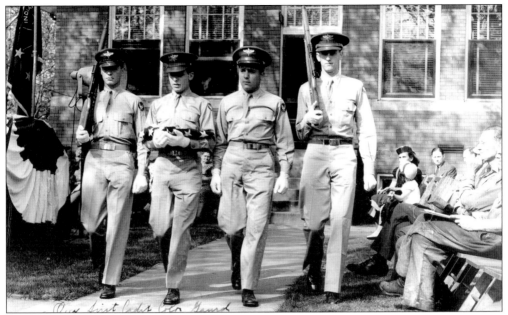

On May 12, 1944, a white-gloved color guard of George Field cadets presents Vincennes Steel Corporation with the Army-Navy E flag for excellence in production of deck plates, used to build landing craft at the Evansville shipyard. Workers (who were putting in 65-hour weeks) were given E pins to wear.

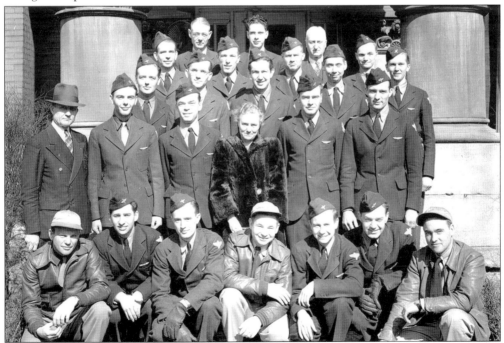

On March 27, 1943, Vincennes University aviation cadets and teachers pose in front of old Vincennes University. Four Vincennes University faculty members gave them eight weeks of ground school, and Frank O'Neal gave flight training at his airport across the river. In 1942–1943, the university taught 62 cadets.

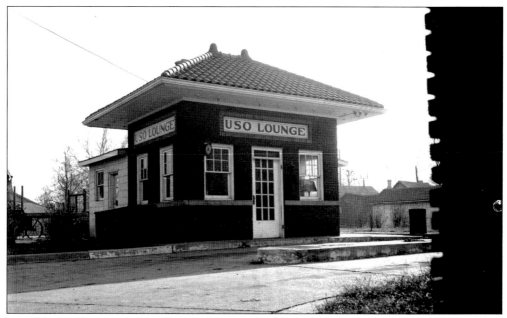

In 1945, an old gas station on Eighth Street and Wabash Avenue, near the railroad depot, was converted into a USO lounge, a small canteen for servicemen traveling by train. In 1946, it became the Dixie Drive-In. Note the baggage wagon in the left background.

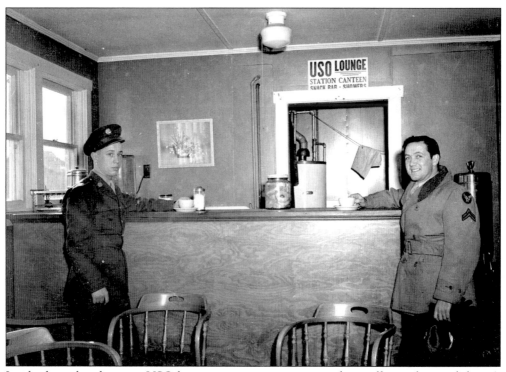

Inside the railroad station USO lounge, two servicemen enjoy hot coffee at the snack bar. A jar of fresh donuts is between them on the counter. In the back room, a hot shower is provided. Most military personnel traveled around the country by train and had priority over civilians.

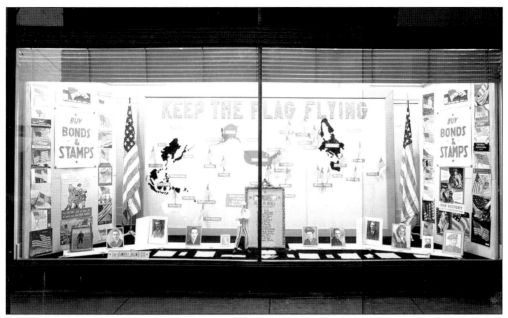

"Keep the Flag Flying," urges a war bond window display at Gimbel-Bond Department Store, at Second and Main Streets, on June 30, 1942. Patriotic fervor was high, with the latest news of four Japanese aircraft carriers sunk at the Battle of Midway.

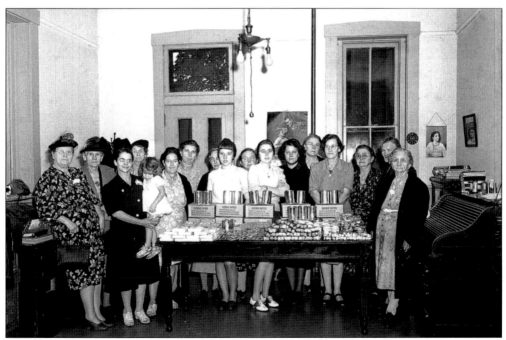

At their quarters in the old King's Hotel, across the alley from city hall, members of the Vincennes Salvation Army prepare shipments of food and other necessaries during World War II. The Salvation Army also provided Christmas food baskets for the needy. Around the corner at 314 Main Street, the Russian Relief Organization shipped packets of food and clothes to a beleaguered ally.

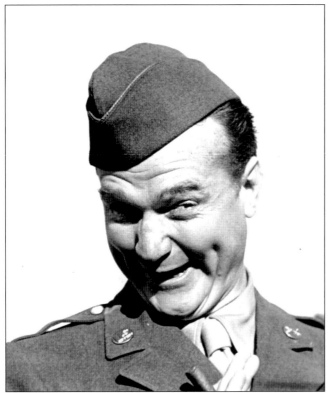

Vincennes native Richard "Red" Skelton (1913–1997) was a big star in radio and films before being drafted in March 1944. At Field Artillery Replacement Center at Camp Roberts, California, he spent a lot of his time clowning around and putting on shows for the soldiers. After one show, he was called in the next morning at 5:00 a.m. to police the area. "That's the first time I ever laid an egg and had to clean it up afterward," Red quipped.

After basic training, Pvt. Red Skelton was classified as an "entertainment specialist" and shipped to Naples, Italy, to entertain the troops. Discharged in September 1945, he went on to star in his top-rated television variety show from 1951 to 1971.

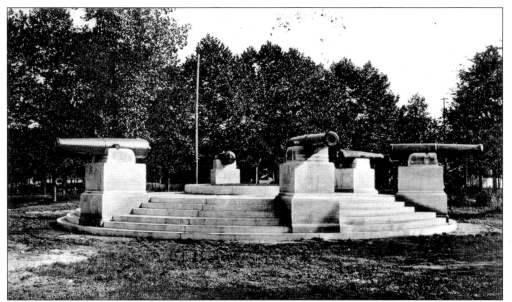

Six Dahlgren cannon from the Battle of Vicksburg, mounted on the 1907 Civil War Memorial in Harrison Park, at Third Street and College Avenue, were melted down in a World War II scrap metal drive. There were also drives to save rubber, tin, paper, and even kitchen grease. School children also collected milkweed pods for life jacket stuffing.

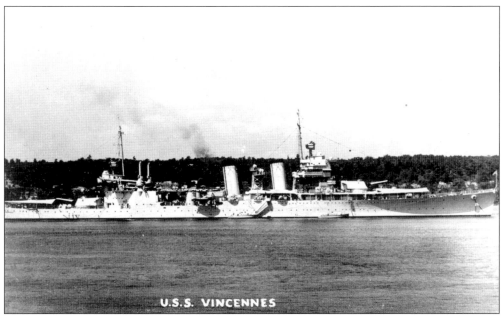

The heavy cruiser *Vincennes*, launched in 1936, distinguished itself in the early days of World War II. In April 1942, it escorted the carrier *Hornet* on the Doolittle Raid against Japan. At the Battle of Midway, in June, it gave antiaircraft protection for the carrier *Yorktown*, and the next month it was at Guadalcanal. On August 9, 1942, the *Vincennes* and three other cruisers were sunk in a battle at Savo Island.

On February 8, 1944, Matthew W. Welsh Sr. (standing in foreground) announces to the city War Finance Committee that the fourth war bond drive will honor Congressional Medal of Honor recipient 2nd Lt. Gerry H. Kisters, a former resident of Vincennes. War Finance Committees sold a total of $185 billion in bonds to over 85 million Americans. Even children bought Liberty stamps each week in their schools.

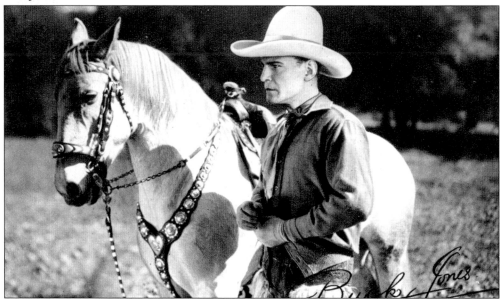

Cowboy movie star Buck Jones, shown here with his horse Silver, was born Charles Frederick Gebhart in Vincennes on December 12, 1891. While appearing in Boston for a war bond drive, Jones was caught in the disastrous Cocoanut Grove fire on November 28, 1942, and died two days later.

Five

INDUSTRY
AND GOVERNMENT

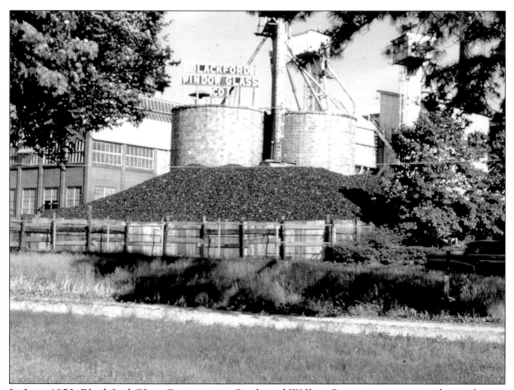

In June 1950, Blackford Glass Company, at Sixth and Willow Streets, was at its peak, employing 200 glassworkers, mostly of Belgian descent. Coming here in 1903, the factory made handblown window glass and, in 1924, switched to drawn sheet glass. It closed in 1966, in part due to failure to modernize, in part due to foreign competition.

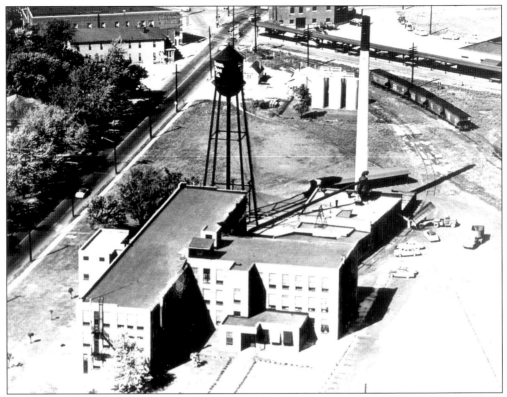

Brown Shoe Company factory, on Washington Avenue, is seen in an aerial view around 1957. Started in 1926, the company employed 500 people in low-paying jobs that were sought after during the Depression. Its trademark was Buster Brown. It closed in 1971 and later burned, due to arson, on February 13, 1978.

Autolite (later Prestolite) battery factory, built in 1947, was the city's bid to join in the postwar boom. Visitors coming in on Highway 41 were impressed by the factory's well-trimmed lawn and rosebushes. After it closed in 1985, the factory and the soil around it were found to be polluted with lead, requiring a Superfund cleanup.

Fort Wayne Paper Company, at Willow and Fourth Streets, is pictured about 1930. Established in 1904 as Empire Paper Company, it became a subsidiary of Fort Wayne Corrugated Paper Company, producing cardboard containers and wrapping paper. It closed in 1960 and was torn down in 1970. Its site is now the Spirit of Vincennes Rendezvous grounds.

Twenty-foot-high ricks, each containing 350 straw bales (used for making corrugated boxes by Pomeroy Corrugated Box Company), were a familiar sight along North Sixth Street from the 1930s to the 1960s. When wet, they gave off a musty-sweet smell of new-mown hay. It seemed that almost every summer, a rick spontaneously combusted, resulting in a spectacular fire.

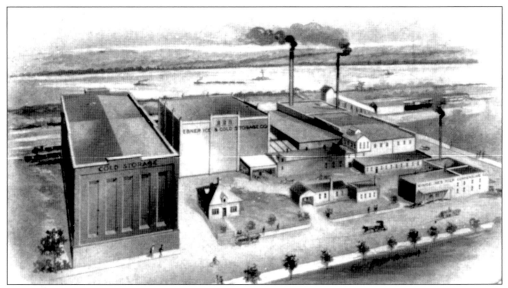

This is a bird's-eye view of Tip Top Creamery, at Chestnut and Locust Streets. Established in 1908 as Vincennes Milk Condensing Company, it made ice cream, butter, cottage cheese, cream, and Meadow Gold milk under manager Sebastian Risch for 50 years. The adjoining Ebner Ice Company supplied blocks of ice to keep the products cool.

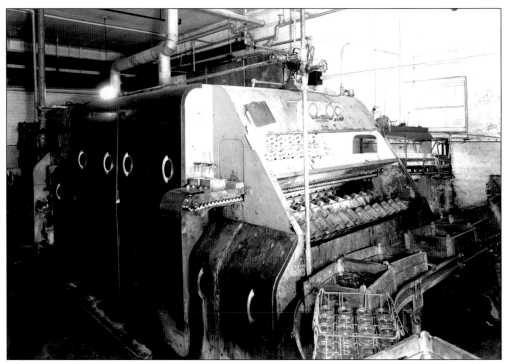

The Tip Top Creamery bottle-washing machine is shown about 1940. Meadow Gold dairy products were home delivered daily by a fleet of milk trucks, and empties were washed and reused. During World War II, gasoline was scarce and deliveries were made with horse-drawn wagons. Vincennes University acquired the plant in 1965 and tore it down as part of a campus expansion.

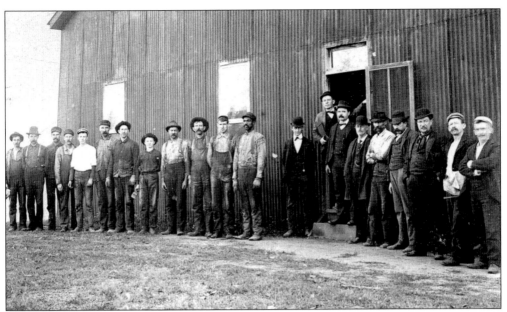

Organized in 1898, Vincennes Steel Corporation is the oldest manufacturing firm in town. Located on Old Terre Haute Road (now Oliphant Drive), it was originally Vincennes Bridge Company, which specialized in the construction of small I-beam spans and pony trusses. In 1932, it became Vincennes Steel, under Pres. Hugh Q. Stevens, and applied assembly-line methods to the fabrication of steel highway bridges.

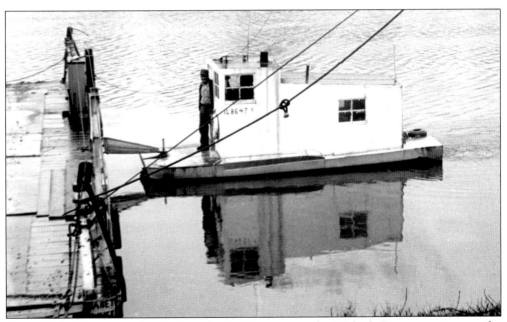

Isaac Caldwell operates the St. Francisville Ferry across the Wabash River sometime in the 1950s. Toll for a car was 35¢ one way. Caldwell had the ferry from 1938 until its demise in 1970. There had been a ferry here since 1803, and earlier, in 1779, George Rogers Clark's army crossed here. A great Sunday treat was to drive three miles down the Sixth Street Road along the route of Clark's march and take the ferry.

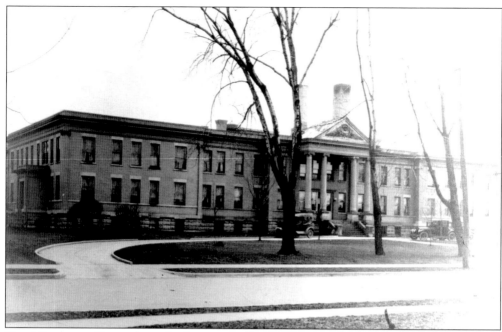

Good Samaritan Hospital was the first county hospital in Indiana when it opened in 1908. The impressive neoclassical structure, designed by architect J. W. Gaddis, was built of buff brick on the square bounded by Seventh, Eighth, Nicholas, and Dubois Streets. This picture shows it after the wings were added in 1918 and 1922 and before the Memorial addition was built in front of it in 1950.

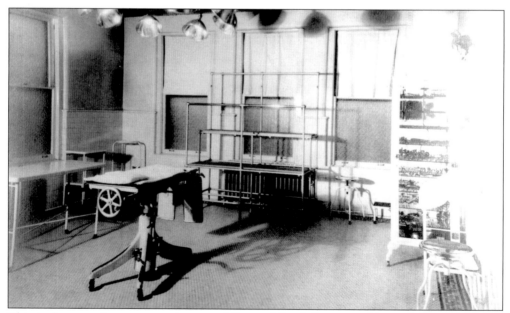

This is the operating room on the second floor of Good Samaritan Hospital. Large arc lights hang above the simple operating table. In the background is the framework of a gallery where physicians and medical students can watch operations. In the case to the right are $500 worth of surgery instruments.

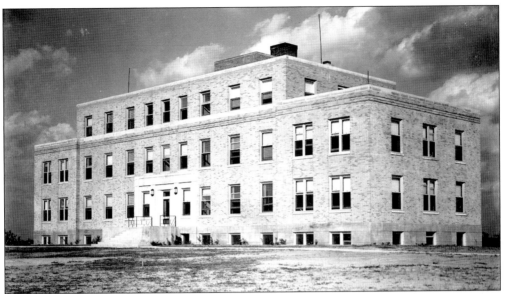

In October 1937, Hillcrest Tuberculosis Hospital stands at the crest of Sand Hill, two miles east of town. About 1880, a city pesthouse was set up here to quarantine people with contagious diseases. In the early 1900s, it was known as Dead Man's Hill because of its challenge to the hill-climbing abilities of flivvers. Knox County built the hospital here in 1935 to treat tuberculosis, known as the white plague—a major health problem in the 19th and 20th centuries.

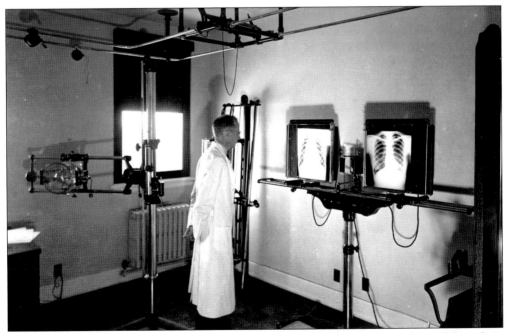

In charge of Hillcrest for many years, Dr. Frank Stewart stands by an X-ray machine. Tuberculosis required monitoring by X-ray and sometimes the deflation of diseased lungs. The discovery of new drugs in the late 1960s ended the need for extended hospital care, and the hospital closed in 1971. Stewart then went into private practice and was remembered as always conducting lung screening for city schools.

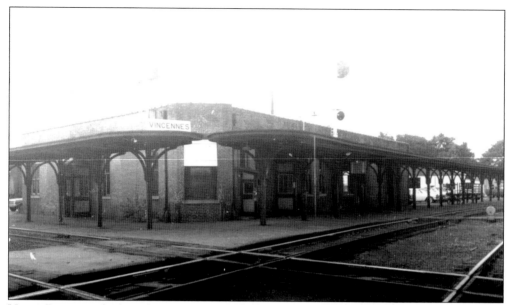

Union Depot was built at the crossing of the Baltimore and Ohio and the Chicago and Eastern Illinois Railroads in 1871. It was a required stop for passenger trains, and many famous people, including several presidents, were here, if only briefly. This photograph shows the depot in the 1950s, after the razing of the hotel in 1937 but before the removal of the platform canopy in the 1970s.

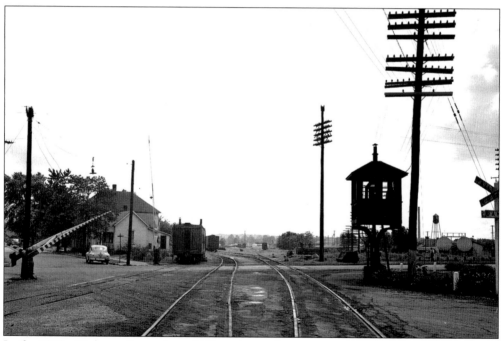

In the 1940s, Hickman Street (now College Avenue) crosses six sets of railroad tracks. After a horrific car-and-train accident in August 1910, Baltimore and Ohio Railroad erected the switch tower, on the right, to regulate crossing bars and to control track switches in the Baltimore and Ohio yard, in the background. Squibb Distillery, on Fourth Street, is on the left.

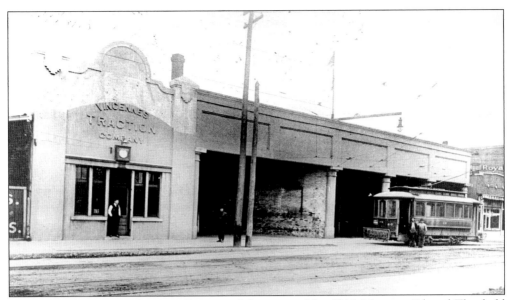

Pictured is the streetcar barn on Fairground Avenue in May 1919. Manager Edward Theobold is in front. Service began in 1883. The tracks went five miles from Lakewood Park down Fairground Avenue and Seventh Street to Main Street, down Main Street to Second Street, out Second Street to Swartzel Avenue, and down Swartzel Avenue to Columbia Park. Fare was a jitney (nickel). In 1938, buses replaced trolleys. The carbarn was razed in May 1962.

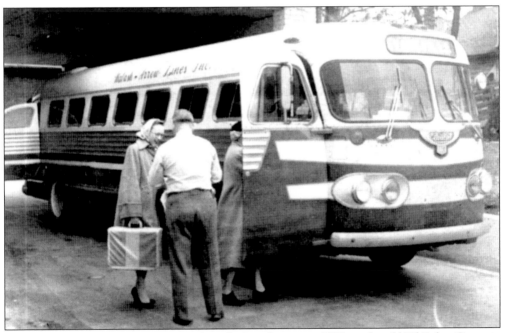

Vincennes Bus Station was at Seventh and Main Streets in 1957, in the old Ed Baker Grocery, with a second-story addition on the side, where buses were loaded. Inside were a waiting room, restaurant, and grill. Beginning in 1947, it was used by Indianapolis-Vincennes Coach, Wabash Valley Coach, Arrow Coach, Greyhound, and Bluebird lines. It was torn down to make way for the *Sun-Commercial* newspaper offices in 1966.

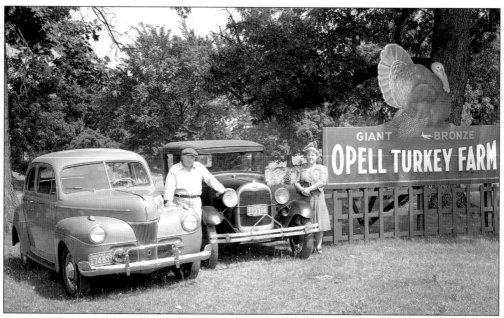

In June 1941, Luther and Gladys Opell stand in front of their new turkey farm, on Highway 61, near the Indiana Presbyterian church, where the road makes a couple of hairpin turns around a pond. Back then, turkey was mostly for Thanksgiving and Christmas. Before Thanksgiving, hillsides were covered with droves of doomed gobblers. Now turkey growing is more of an industry, and turkeys rarely see the light of day.

When he sold out in 1961, Orval Meyer had been "the Peony King of Knox County" for 40 years. His 110-acre farm, on old Bruceville Road, was the biggest of a dozen local farms growing the peony (pronounced "piney" by locals). The countryside was covered with fields of large pink, red, white, and cream-colored flowers. Meyer shipped by rail express all over the Midwest. Now flowers are imported from Central America.

In 1950, the Bert E. Yates Orchard, near Oaktown, was one of several big apple and peach orchards in the county. Some like Simpson and Dixie Orchards have become housing developments. Others like Nesbitt, Big Peach, McKinley, and the new Apple Hill still remain.

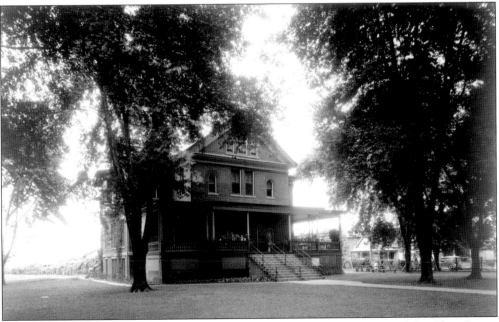

From 1898 to 1976, Knox County Orphanage, at Washington Avenue and St. Clair Street, provided care for 30 to 50 children who were parentless because of accident, disease, or abandonment. It closed on March 1, 1976, and burned down on February 27, 1977, due to arson. The site is now used by the Knox County Association for Retarded Children. (Photograph courtesy of Indiana Division, Indiana State Library.)

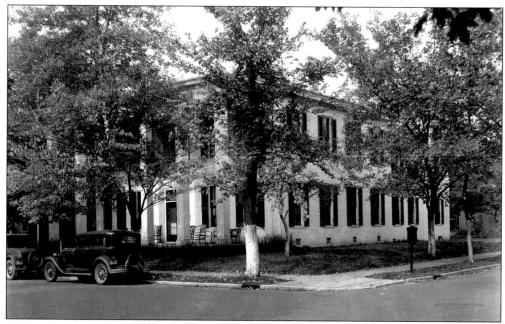

The American Legion, at Fourth and Buntin Streets, stands on the site of Knox County's first brick courthouse in May 1940. The courthouse was torn down in 1863 by William Heberd, who replaced it with the present home. In 1931, the American Legion bought it and added a two-story portico and, later, a reception hall.

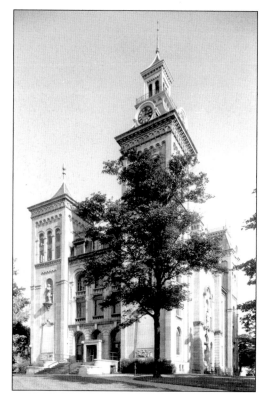

The third Knox County Courthouse was built in 1873–1874 on the site of the second courthouse, on the block bounded by Seventh, Eighth, Busseron, and Broadway Streets. It was built of limestone in the style of a Norman castle. The statue on the tower to the left is of George Rogers Clark. It is the earliest memorial to him.

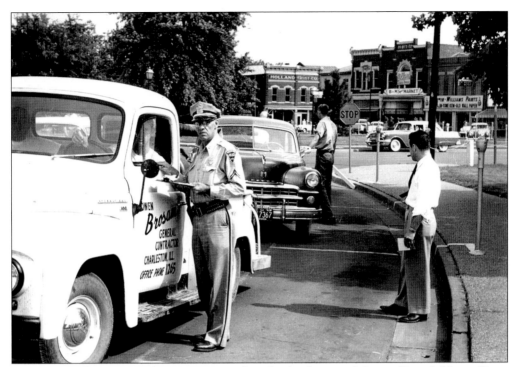

Vincennes policemen conduct a routine safety check of automobiles on Patrick Henry Drive sometime in the 1950s. They would test lights, brakes, and wipers. The khaki uniform is typical of the period.

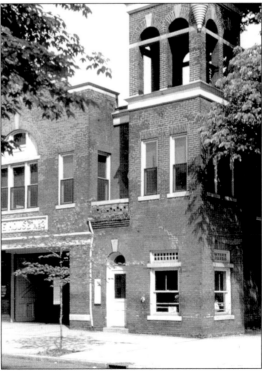

Hose House No. 3 is seen in June 1950. Built at Second Street and Rosedale Avenue in 1897, it had a dormitory upstairs for firemen and a loft for hay to feed the fire horses. On the right side was a tower to locate fires. It was torn down by Vincennes University in 1988 as part of a campus expansion. Other fire stations were No. 1 on South Fourth Street, No. 2 at Sixth and Harrison Streets, and No. 4 at Fourteenth and Vigo Streets.

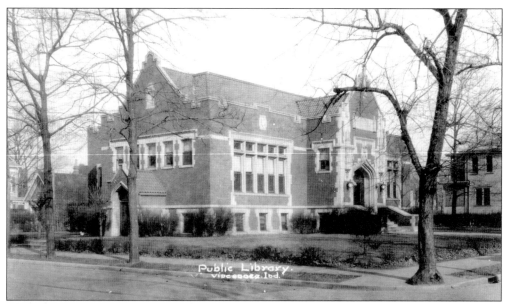

In 1919, Vincennes built a library in the popular Collegiate Gothic style at Seventh and Seminary Streets, thanks to a Carnegie Foundation grant. In 1978, a modern wing was added, and it became Knox County Public Library. The difference in architectural styles was handled by putting a high brick wall around the old part.

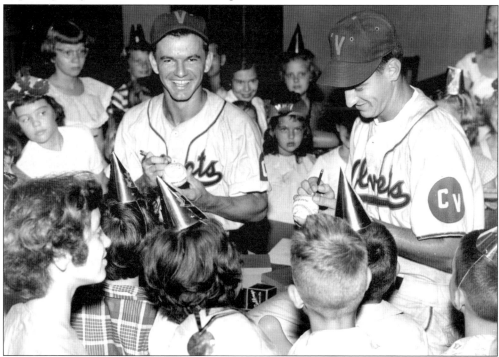

On July 26, 1951, the final story hour of the summer reading program is a party, with Vincennes Velvets players Ed Rellergert and Wayne Haas autographing baseballs. The program had a baseball theme. Children were on teams; reading four books was a home run, and cardboard players moved around a diamond with each book read. (Bill Offutt photograph.)

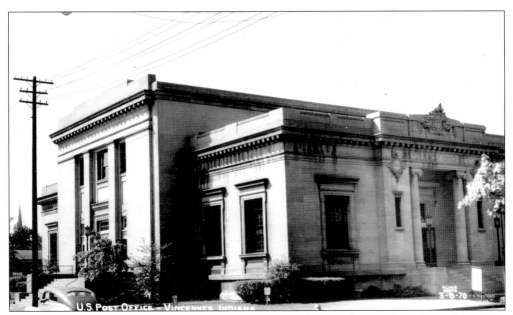

In 1907, the city's first post office built exclusively for handling mail opened at Fifth and Busseron Streets. In 1936, a two-story addition was made on the east side. In 1969, the post office moved to a new Williamsburg-style building at Fourth and Broadway Streets. In 2004, the city police took over the old building.

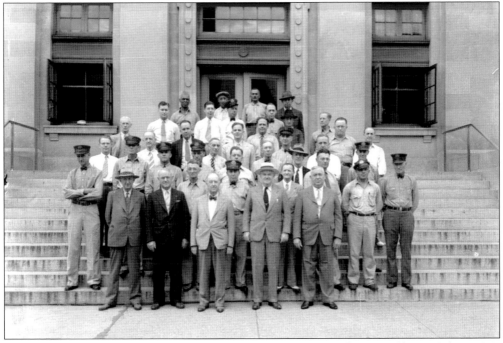

Postal workers stand in front of the Busseron Street entrance to the post office on July 1, 1943. Vincennes had the first post office in Indiana in 1799, when General Washington Johnston was appointed postmaster. At first, people picked up mail at the post office. Home delivery service began in 1887.

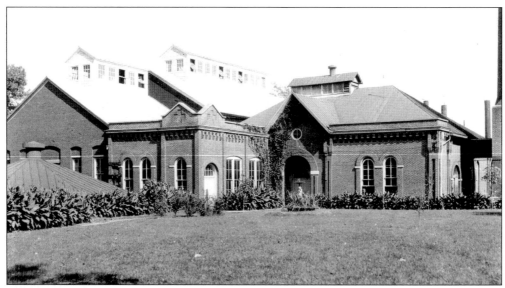

Vincennes Water Supply Company completed its waterworks in the spring of 1887. Now citizens could have running water in their homes, as well as 200 hydrants for fire protection. The tentlike structure to the left is the clear water reservoir. Behind it is the filter house, and to the right is the pump house.

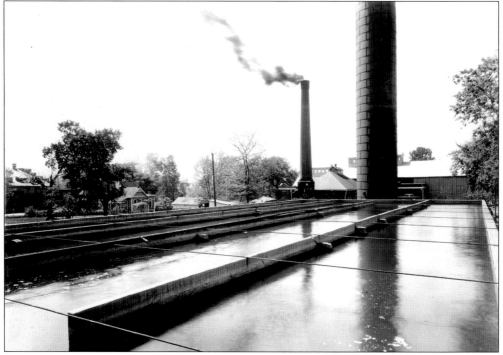

In 1930, large concrete settling tanks occupy what is now the parking lot of Green Auditorium. Water was drawn directly from the nearby Wabash River and left to settle out silt. It was then filtered, treated with lime, and pumped into the 210-foot-tall standpipe, seen in the background. The water sometimes tasted funny when the river was low and effluent concentrations were high.

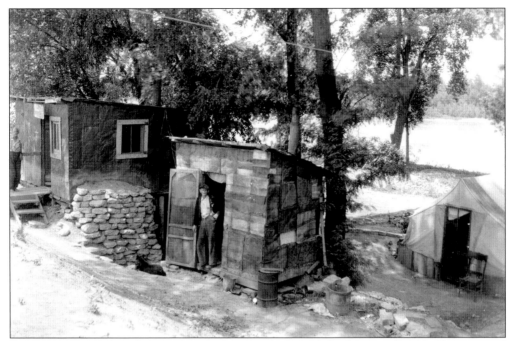

In the Great Pearl Strike of 1905, freshwater pearls sold for $500 to $1,000. Shanties and houseboats of pearl fishermen lined both sides of the river for a half-mile. By 1907, the mussel beds were depleted, but the shantytown remained. As seen here, Pearl City in 1934 is a squalid squatter camp of tar paper shacks and tents on the riverbank below Willow Street.

In February 1936, residents of Pearl City were resettled in Sunset Court, built in 1935 as Vincennes's first public housing. Using bricks from buildings razed to make way for the George Rogers Clark Memorial, Works Progress Administration (WPA) workers built 20 shotgun-style houses on the city's southwest side. Five years later, Bowman Terrace was built on the north side. In 2005, Sunset Court was torn down to make way for municipal baseball fields.

Families celebrate the Fourth of July in 1941 with a picnic in Gregg Park, followed by swimming at Rainbow Beach, playing on swings and slides, pitching horseshoes, and playing the ever-popular game of euchre. The park was created in 1930 on the old county fairgrounds and was named after Mayor Claude Gregg. (Farm Security Administration photograph by John Vachon.)

This photograph and the following two are of the authors of this book growing up in Vincennes. In his first acting role, 13-year-old Richard Day, with a golden goose, is given advice by a mysterious old woman. "She was really the same age as me, but much taller. I had a crush on her. The play was *The Crying Princess and the Golden Goose*. I end up with the princess in the end." This was the first production of Vincennes University Children's Theatre, directed by Amy G. Loomis, held on March 8, 1958, at the Fortnightly Club.

Around 1954, seven-year-old Garry Hall gives a push car ride to his sisters in front of his home at 1302 Perry Street. "I'm in back, pushing my sisters Dorothy and Sherry. The push car actually belonged to my older brother, Bill, who was not present, and if he knew I'd hijacked his car, he would've been very unhappy."

Eight-year-old William (Bill) Hopper sits in his favorite push car, *Green Hornet* No. 6, in front of his home at 917 Busseron Street, around 1947. "My dad used to build toys for me and the kids in the neighborhood. He built the push car with an old auto steering wheel and a hood ornament from an Olds. There's a raccoon tail hanging from the ornament."

ACKNOWLEDGMENTS

Thanks go to the following people and institutions for allowing us to use their pictures and providing us with information: Knox County Public Library, McGrady-Brockman Annex; Brian Spangle, archivist; Vincennes University; Byron R. Lewis Historical Collections Library; Richard King, reference librarian; Jill Larson, library assistant; Vincennes University, Red Skelton Collection; Indiana Division, Indiana State Library; Judge Jim Osborne and the Indiana Military Museum; Cy Deem; Ralph Holscher; the Drs. Hendrix at the Eyeworks; Jim Trueblood; Wilbur Yates; William Hopper; and Garry Hall.

We especially want to thank our wives for their help and moral support: Janet Day, Donna Hall, and Karen Hopper.